IMAGES
of America

# DOWNTOWN
# ROANOKE

To Tyler—

Happy 13th Birthday!

Nelson Harris

From Mom, 2004

IMAGES
*of America*

# DOWNTOWN ROANOKE

Nelson Harris

ARCADIA

Published by Arcadia Publishing
an imprint of Tempus Publishing Inc.
Charleston SC, Chicago, Portsmouth NH, San Francisco

Printed in Great Britain

Library of Congress Catalog Card Number: 2004100101

For all general information contact Arcadia Publishing at:
Telephone 843-853-2070
Fax 843-853-0044
E-mail sales@arcadiapublishing.com
For customer service and orders:
Toll-Free 1-888-313-2665

Visit us on the internet at http://www.arcadiapublishing.com

*To John*

# CONTENTS

# ACKNOWLEDGMENTS

I am grateful for the cooperation and support of numerous persons and organizations without whom this book would not have been possible. Of greatest importance were the support of Kent Chrisman and the staff of the History Museum and Historical Society of Western Virginia (HMHSWV). Their well-organized archives provided nearly all of the photographs included in this work. Much of the information contained in the captions comes from Raymond Barnes' *A History of the City of Roanoke* (1968). I am also indebted to Christ Episcopal Church, Central Church of the Brethren, First Christian Church, First Presbyterian Church, and Calvary Baptist Church for providing historic photographs of their church structures. Further, I am appreciative of the support and encouragement of my editor, Susan Beck. Finally, I am always reminded in projects such as this of the patience and understanding of my wife, Cathy.

# INTRODUCTION

Chartered in 1882, Roanoke's early downtown resembled the Wild West. Clapboard hotels, saloons, livery stables, and general stores faced dirt streets clogged with railroaders, merchants, farmers, and horses. One could hardly imagine this being the beginning of the Roanoke known today. As the Norfolk and Western Railway (N&W) grew and prospered, Roanoke's downtown followed. Within a few decades, the general stores, plying everything from cure-all remedies to harnesses to suits, gave way to the multi-level department stores—Heironimus, Miller and Rhoades, Smartwear-Irving Saks, and Leggetts, to name a few. Rorer Hall, Roanoke's first playhouse, was replaced by the onset of the silver screen as Roanokers flocked to the American, Jefferson, Roanoke, Park, and Rialto Theaters. During the Christmas season police were needed to direct pedestrian traffic across busy streets. Banks and businesses flourished in tall office buildings. Congregations, wishing to demonstrate and express greater influence, moved from A-frame structures into ornate, often Grecian, sanctuaries. Downtown Roanoke was the center of life for the Roanoke Valley.

By the mid-1970s, however, Roanoke's downtown, like that of many other cities, had become encrusted in blight and deterioration. The once packed theaters had dimmed their marquees. The flagship department stores had moved to the suburban malls. Banks now had branches, businesses had "corporate centers" in the counties, and the N&W Railway would soon relocate its headquarters out of Roanoke. Churches found the harvest riper in the neighborhoods, and some moved.

With the coming of the 1980s Roanokers began to dream of a revitalized downtown. The purpose was not to go back and re-create what was, but to move forward with a new vision of downtown that would restore the district's rightful place as a center of culture and commerce and to create a synergy of urban life and creativity. Today, the Market Square is flush with restaurants, artists' studios, and, of course, farmers. Center in the Square offers live theater, art, history, and science museums. Former office buildings from the early 1900s are being converted into downtown living spaces, and business is back. Downtown is hip again.

The images contained in this work provide a century-long collage of places, events, people, and commerce. Some have long ago faded from the collective memory of the city and can now only be interpreted through archival photographs. Other photographs, however, contain images that are still remembered by Roanokers of today—the stores where they shopped, the theaters, the lunch counters, the streetcars, and the schools. Beyond accompanying one down memory lane, *Images of America: Downtown Roanoke* is offered as inspiration for the future. Each image is a testament to someone's planning, determination, creativity, and investment in Roanoke—all elements still in demand today.

In the captions, I have used current street names in an effort to make locations easier to identify. As a native Roanoker, I take pride in my community's history, and, while a book such as this demands much time and energy, it is presented with pleasure. May *Images of America Downtown Roanoke* remind us all of the imagination and public spirit that is Roanoke.

# One
# TURN OF THE LAST CENTURY

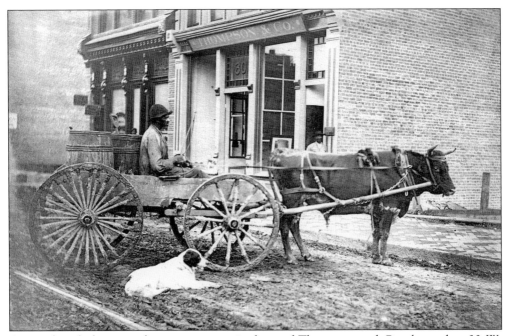

An unidentified man with a wagon stops in front of Thompson and Co., located at 30 W. Campbell Avenue, around 1890. (HMHSWV.)

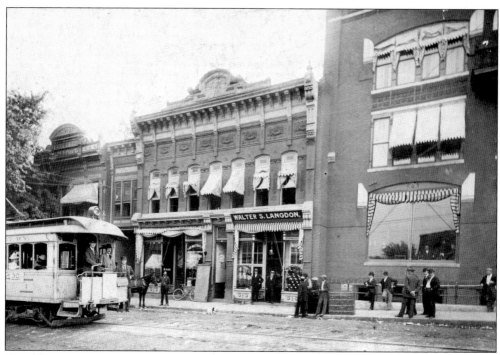

An old streetcar moves along Second Street north of Campbell Avenue in 1890. The building to the right with the large windows is the Ponce de Leon Hotel. (HMHSWV.)

In this picture a high wire artist performs near Rorer Hall (in the center background) in 1892. This would have been near the intersection of Campbell Avenue and Second Street. In the city's early years, numerous circuses and shows passed through Roanoke with performers and sideshows. (HMHSWV.)

The intersection of Jefferson Street and Campbell Avenue looks much different in this photo, taken around 1885. The view looks north on Jefferson. (HMHSWV.)

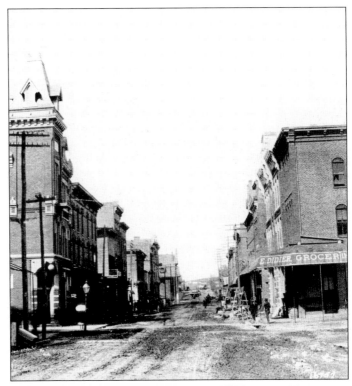

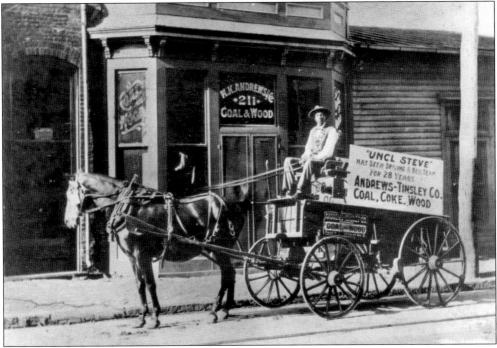

The original owner of this picture identified the driver of the wagon as "Steve," who drove for Andrews-Tinsley and Co., a provider of coal, coke, and wood. This image was taken along Salem Avenue in the 1890s. (HMHSWV.)

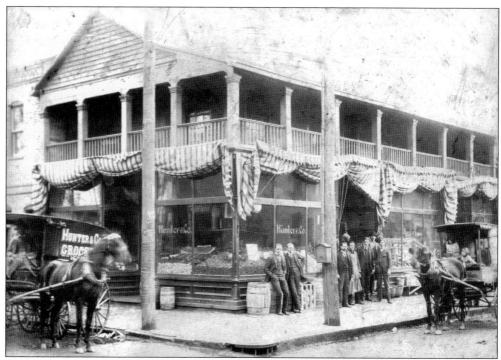

Hunter and Co., one of Roanoke's early grocers, was located at the north corner of Second Street and Salem Avenue. This photo was taken in 1905. (HMHSWV.)

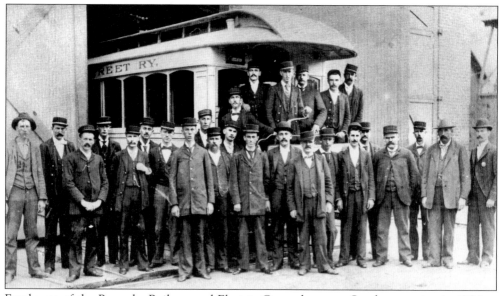

Employees of the Roanoke Railway and Electric Co. gather on a Sunday morning in 1894 at the streetcar barn on "Duck Alley." The alley was between Salem Avenue and the railroad tracks on the east side of Fifth Street, SW. (HMHSWV.)

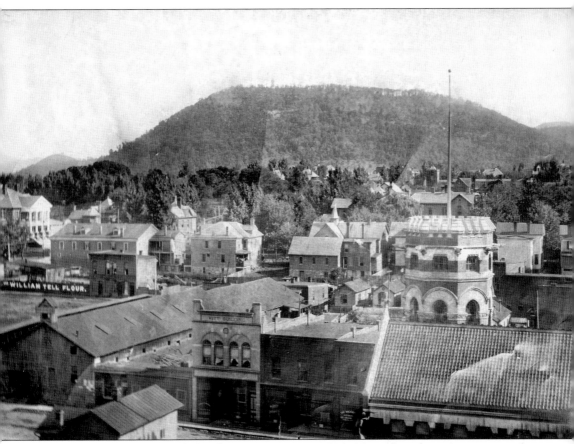

This is a panoramic view of the downtown area in 1910. Note that the ornate tower of Roanoke's first federally built post office is prominent in the right foreground. While Roanoke was experiencing tremendous growth at this time, the downtown area still had a visibly residential quality. The structure in the left background with the columns is the Elks Home. Mill Mountain is in the background; its base, though not visible here, was still undeveloped farmland. (HMHSWV.)

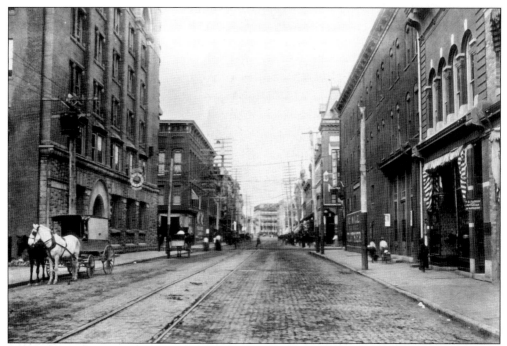

This 1901 image shows a view looking west on Campbell Avenue from Jefferson Street. To the left is the base of the Terry Building, which was razed in the late 1920s. The back side of the Ponce de Leon Hotel can be seen at the far end of the street. (HMHSWV.)

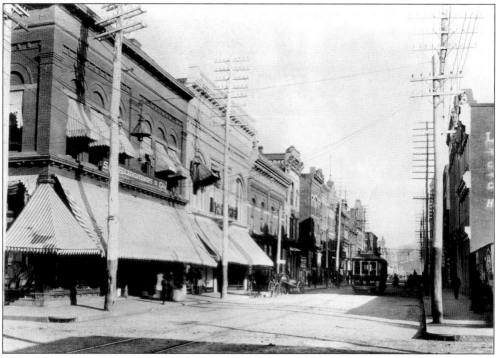

Here is the intersection of Campbell Avenue and First Street, c. 1905. The building in the left foreground with awnings is S.H. Heironimus Co. (HMHSWV.)

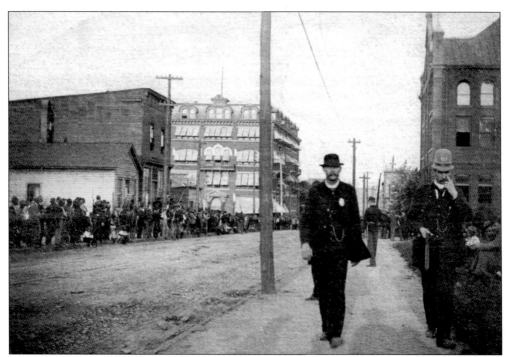

In 1892, Roanoke celebrated its 10-year anniversary with a decennial parade. Here citizens line Campbell Avenue near the intersection with First Street. (HMHSWV.)

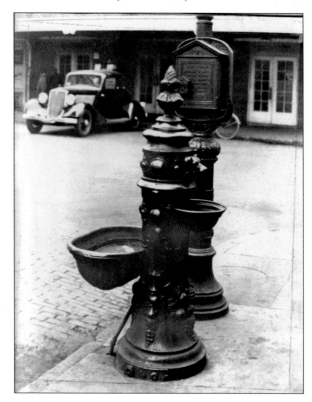

The well-known "Dog Mouth Fountain" sat on the northwest corner of Salem Avenue and First Street, SE, for years. This picture of the fountain was taken in 1930. The legend at the time was that those who drank from the fountain, though they leave Roanoke, would always return. (HMHSWV.)

15

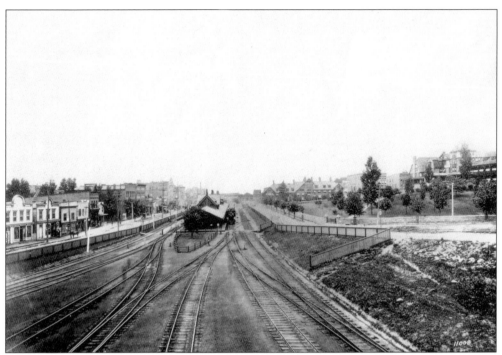

The N&W passenger depot, located in the middle of the tracks, served Roanoke and her visitors for several years. This photo is dated 1902. The buildings to the left are hotels and saloons. The Hotel Roanoke is to the right. (HMHSWV.)

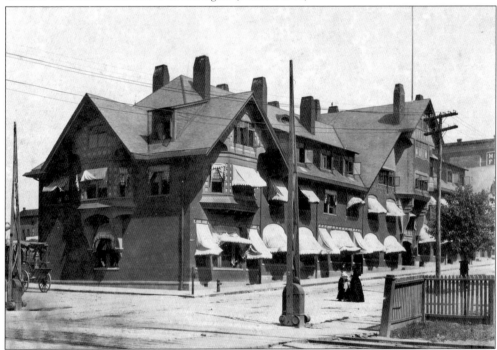

The original headquarters for the N&W were housed in this building, which was built in 1883–1884 on the corner of Jefferson Street and First Street, NW. (HMHSWV.)

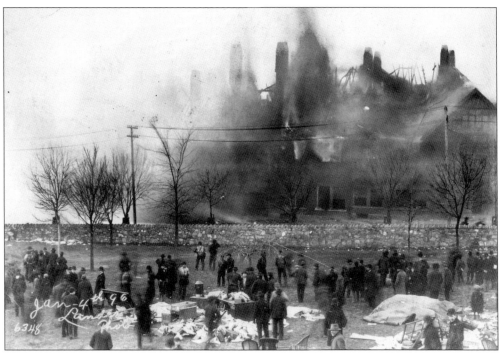

A fire engulfed the N&W office building on January 4, 1896. Employees saved what they could, as evidenced by the furniture and other items on the lawn, but the building was a total loss. Notice the numerous chimneys still standing as the wood structure collapses. (HMHSWV.)

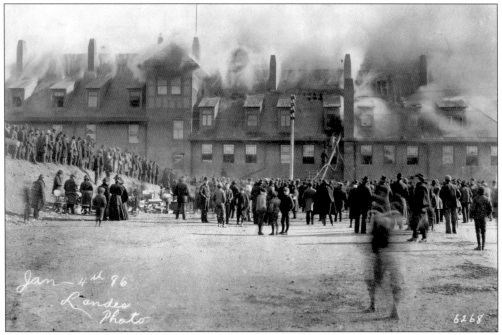

Here is another view of the devastating fire that destroyed the railway offices. At the time no paid professional fire protection service was available, so volunteers did their best to contain the blaze. (HMHSWV.)

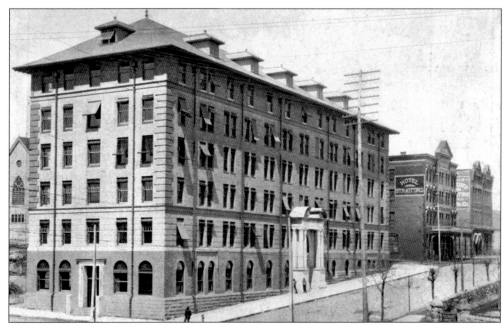

With the destruction of the railway's headquarters, the N&W erected this office building in the same location. This image, dated 1904, does not show the addition that was later added to the general office building. The buildings in the background are old hotels, one of which is the Stratford. (HMHSWV.)

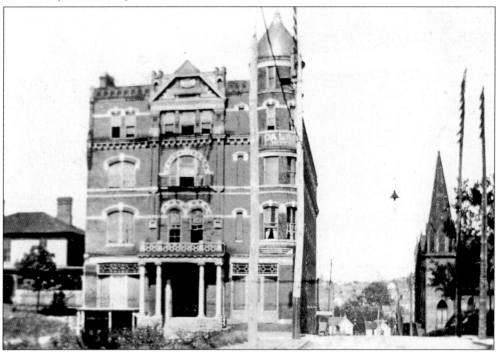

This was the Palace Hotel, one of many such establishments in the city at the turn of the last century. The hotel was located at 39–43 Railroad Avenue on the corner of Norfolk Avenue and First Street. This photo was taken around 1890. (HMHSWV.)

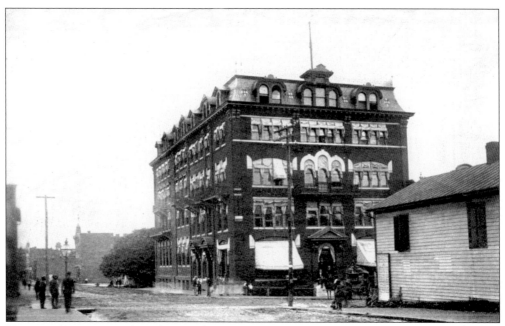

Here is the intersection of Second Street and Campbell Avenue as it looked around 1890. (HMHSWV.)

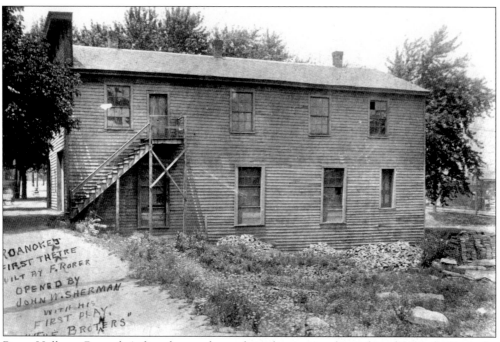

Rorer Hall was Roanoke's first theater, located at what is now the parking lot for the Roanoke Times along Campbell Avenue. The upper floor was once used as a courtroom and jail. Ferdinand Rorer built the structure, and the first play presented there was John Sherman's *The Brothers*. The photo is dated 1876. (HMHSWV.)

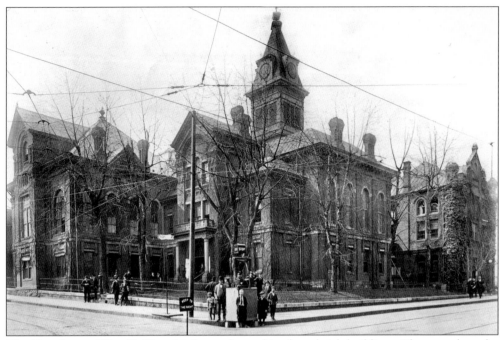

The Courthouse (City Hall) and jail were housed in these brick buildings. They stood on the southwest corner of Campbell Avenue and Second Street where the present-day municipal building is located. This photo was taken in 1910. (HMHSWV.)

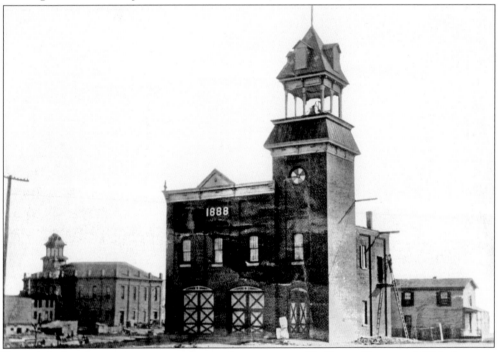

Roanoke's first fire station was on the northeast corner of Jefferson Street and Kirk Avenue. The building was erected in 1888, and this photo was taken in 1890. The structure in the left background is the market building. (HMHSWV.)

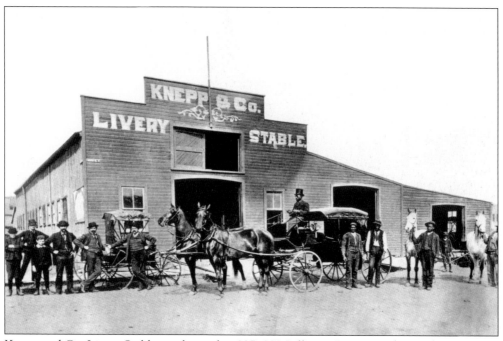

Knepp and Co. Livery Stable was located at 327–329 Jefferson Street, on the northwest corner of Jefferson Street and Church Avenue. The Knepp brothers are standing next to the horseless carriage. The last livery stable, owned by Archibald Greenwood, closed in 1921. (HMHSWV.)

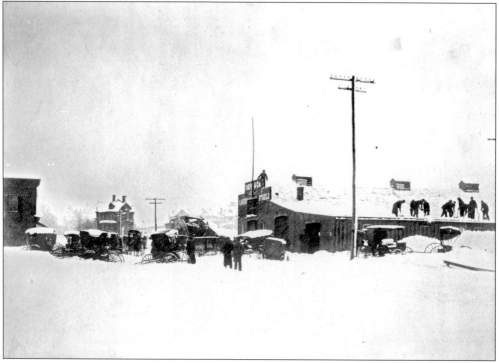

There was a record snowfall in Roanoke on December 16, 1890. Men are seen here shoveling the roof of Knepp's Livery to prevent collapse. (HMHSWV.)

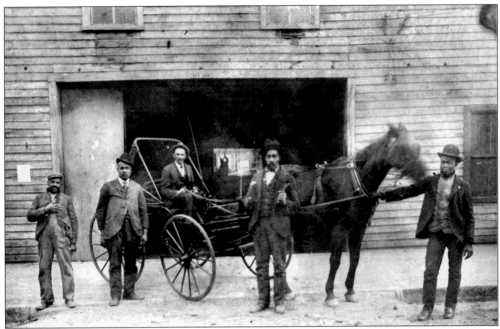

A livery stable was located at the southeast corner of Second Street and Luck Avenue. The men in this photo are, from left to right, Joe Blair, Sam Calloway, John Roberts (in the buggy), Jim Casey, and Clarence Johnson. This image is undated and may show Horton's Livery Stable. (HMHSWV.)

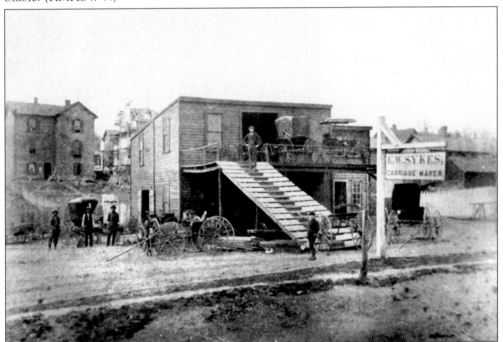

In this c. 1900 image, the carriage-making business of Edward Sykes is shown. Mr. Sykes also operated a grocery. By the mid-1900s, however, he had given up both and was working for the railroad. (HMHSWV.)

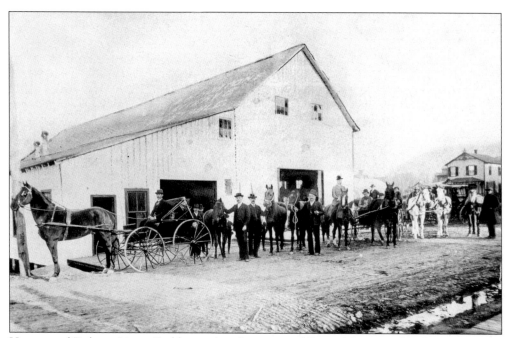

Horton and Roberts Livery Stable stood at the corner of Second Street and Kirk Avenue. The carriages from the stable often carried rail travelers to Red Sulfur Springs Resort in Catawba. This image was taken around 1894. (HMHSWV.)

The cigar factory and store, owned and operated by John B. Ragland, was located in the 100 block of Campbell Avenue. Pictured in this 1905 image are, from left to right, Holman Ragland, George Dean, William Swain, a wooden Indian, and J.B. Ragland. Harry J. Kidd's "Carbon Studio" was located on the second floor. The sign in the window advertises Wrigley's gum. (HMHSWV.)

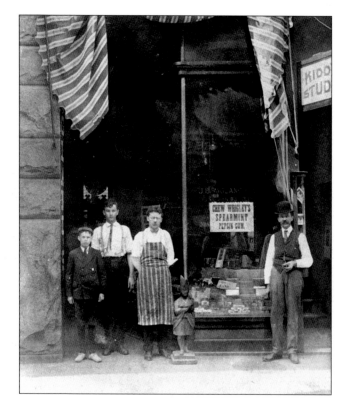

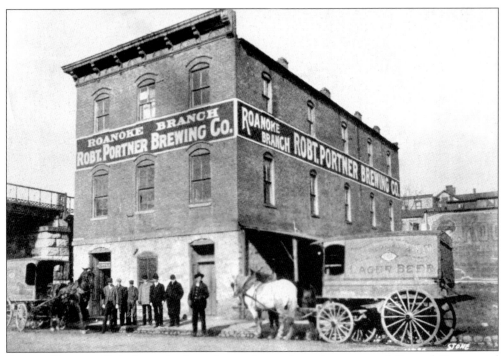

Portner Brewing Co.'s Roanoke branch was located at the corner of Second Street and Shenandoah Avenue. This photo was taken around 1903. (HMHSWV.)

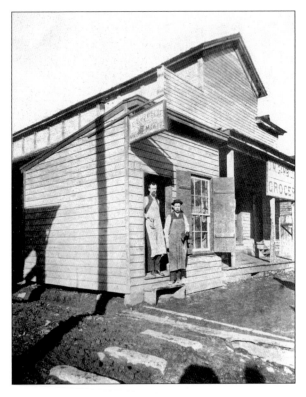

This interesting image shows an old tobacco warehouse on the site of the N&W freight station, which is now the Transportation Museum. The men are standing in the doorway of Edward Proffitt's shoemaking business; one of the men may be Mr. Proffitt. Located beyond them is the grocery of James M. Gambill. The photo was probably taken around 1895. (HMHSWV.)

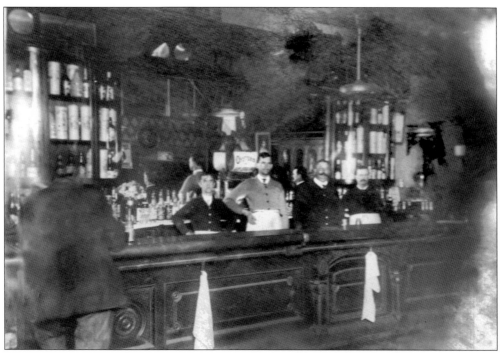

Here is the interior of the Capitol Saloon, previously known as the Raleigh Café, c. 1908. The saloon was located at 23 W. Salem Avenue. George Hacke is the first man behind the bar on the left; the others are unidentified. The sign in the middle reads, "Oysters Upstairs." (HMHSWV.)

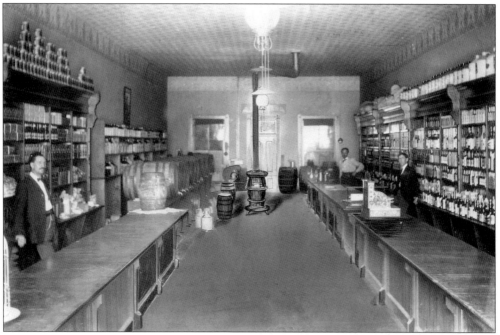

Dillard's Liquor Store was located at the corner of Jefferson Street and Norfolk Avenue. This image was taken around 1900. The 1892 Roanoke city directory listed 46 saloons operating in the town limits. Bartenders were often billed as "mixologists." (HMHSWV.)

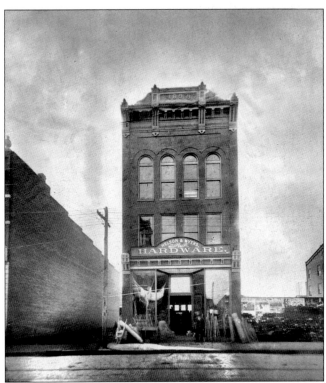

Nelson and Myers Hardware was built in 1897. A.H. Nelson and H.H. Myers' store was located at 207 Second Street, NW, and dealt in both wholesale and retail goods. This photo was taken around 1900. (HMHSWV.)

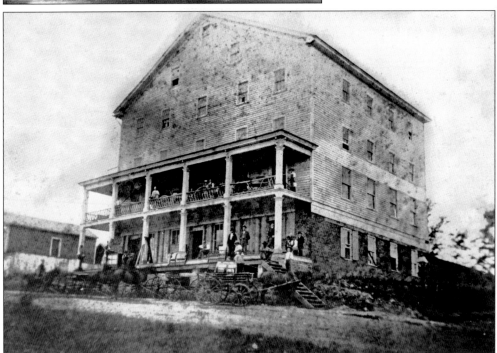

Kefauver and Sons Repository was also known as "Kefauver's Folly." It carried just about everything and sat where the present-day municipal building is located. This photo was taken in the mid-1880s. (HMHSWV.)

Bell Printing Co., shown here about 1885, was the forerunner of the Stone Printing Co. The building was located on the corner of Second Street opposite the Ponce de Leon Hotel. The men pictured, from left to right, are Pryor Fitzgerald, F.R. Hurt, H.O. Adams, J.R. Thomas, and Joe Carper. (HMHSWV.)

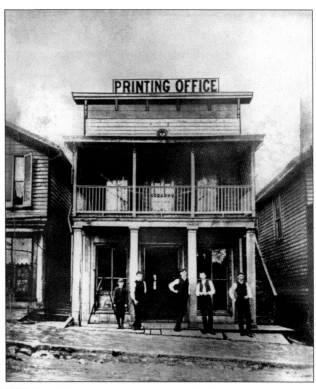

Perhaps these men were taking a break or decided to find a unique location to pose for a photograph around 1900, but here they are at the early home for *The Roanoke Times*, "Daily and Weekly." In 1892, four newspapers served Roanokers: *The Evening World*, *The Daily Record*, *The Roanoke Times*, and *The Sunday Critic*. (HMHSWV.)

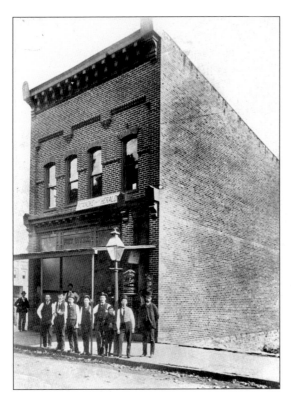

By 1889, the date of this photo, another news journal was on the scene—*The Roanoke Daily Herald*. It was housed at 20 Third Street, SW. The building also contained Roanoke Stock Exchange and Investments, Ltd., and a post office. (HMHSWV.)

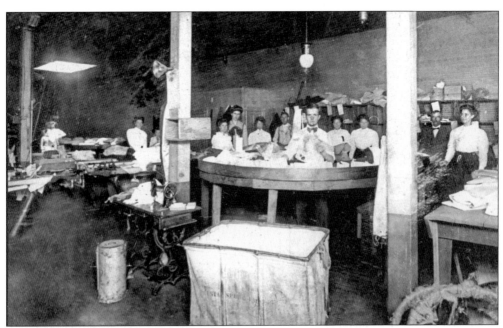

Employees of the Roanoke Steam Laundry tend to their work in this c. 1890 image. The laundry was located at 129 Kirk Avenue, SW. (HMHSWV.)

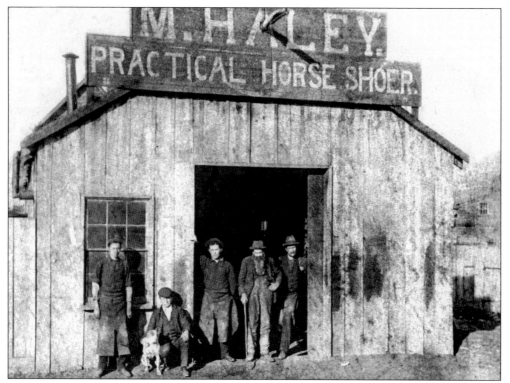

Michael Haley opened his blacksmith shop prior to 1891 at 30 W. Church Avenue, near the intersection with Jefferson Street. His residence was located across the street. The photo was probably taken around 1895. (HMHSWV.)

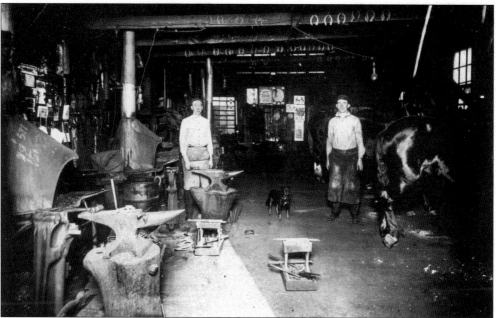

Tom and Pete Haley are shown inside Michael Haley's horse shoeing establishment in 1895. (HMHSWV.)

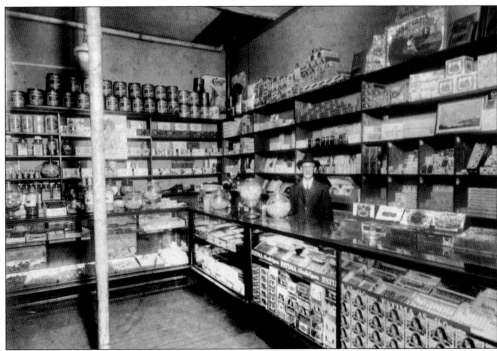

This undated photo shows the interior of a cigar store that operated at the corner of Campbell Avenue and Second Street. (HMHSWV.)

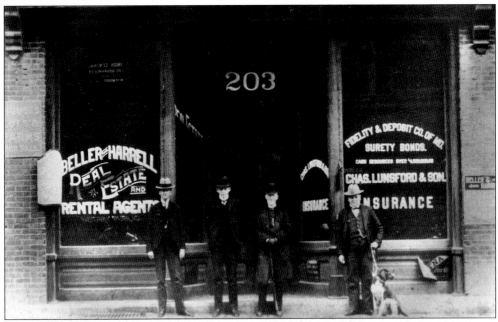

Charles Lunsford and Son began selling insurance in Roanoke in the early 1880s, making it one of the oldest firms still in the city. In an 1892 ad, they wrote, "Write insurance of every kind—fire, life, accident, steam boiler, plate glass, and tornado insurance." This was their location in 1902, on the 200 block of Jefferson Street, along with Beller and Harrell Real Estate. (HMHSWV.)

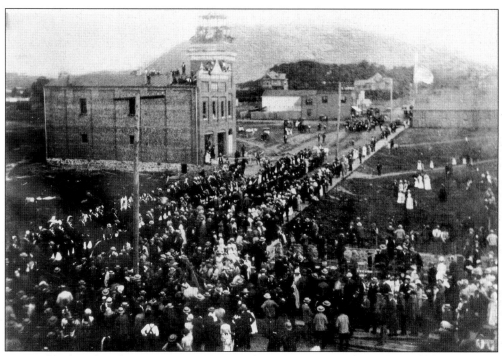

A crowd gathered at the intersection of what is now Jefferson Street and Campbell Avenue to witness the laying of the cornerstone for the Masonic Temple, c. 1887. (HMHSWV.)

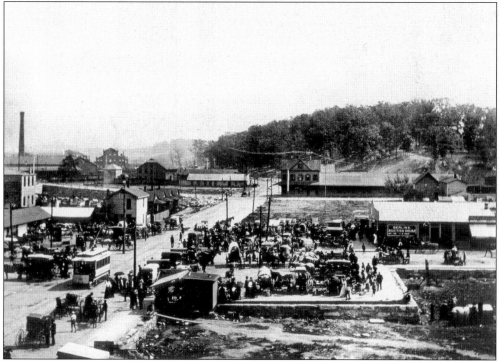

Pictured here is Market Square, c. 1892, with Berlin's Auction House in the right foreground. (HMHSWV.)

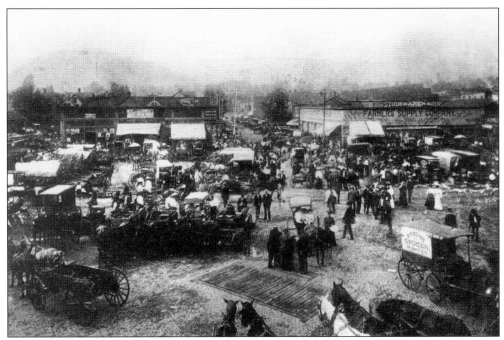

This is another shot of Market Square from a different perspective, *c.* 1898. Signs around the market advertise the Farmer's Supply Co., Studebaker Wagons, and Antone Grocer. (HMHSWV.)

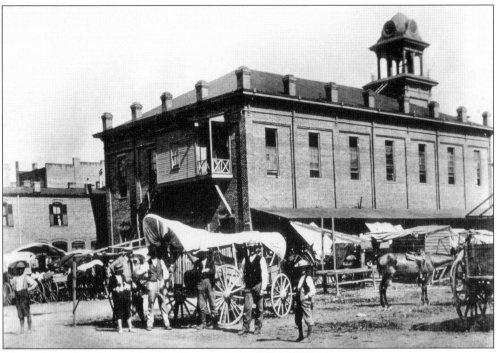

This is Roanoke's first market building, *c.* 1889. (HMHSWV.)

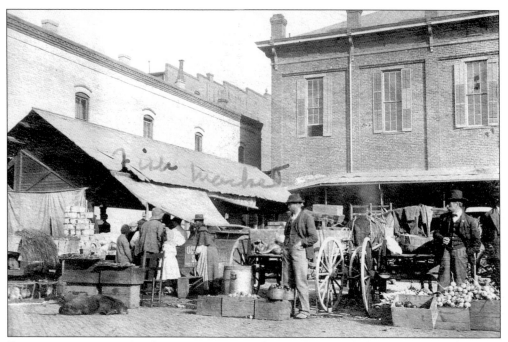

For over a century vendors have come to Roanoke's market to sell their produce, flowers, and crafts. Here are some vendors in the market area, *c.* 1890. (HMHSWV.)

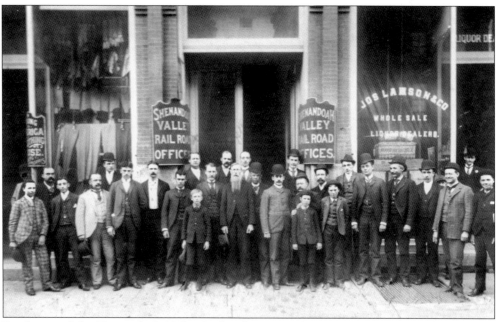

Employees of the Shenandoah Valley Railroad Co. pose for a picture outside the front of their office at the corner of Jefferson Street and Norfolk Avenue in 1889. The Shenandoah Valley Railroad was later acquired by the N&W. (HMHSWV.)

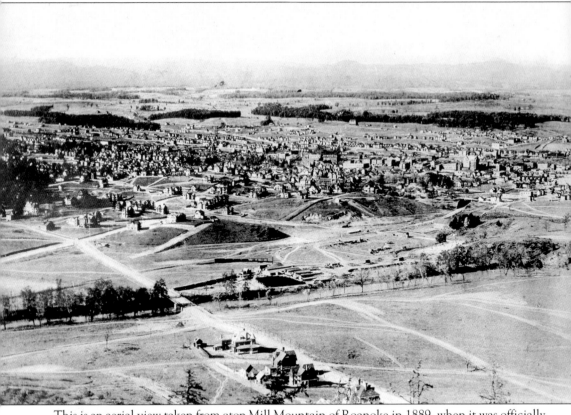

This is an aerial view taken from atop Mill Mountain of Roanoke in 1889, when it was officially only seven years old. It had come along way from being called "Big Lick," as it now was the burgeoning intersection for the lines of the N&W and Shenandoah Valley Railroads. The boom of the 1880s and 1890s would be mild in comparison to the growth Roanoke would experience over the course of the first half of the 20th century. (HMHSWV.)

# Two
# PUBLIC BUILDINGS

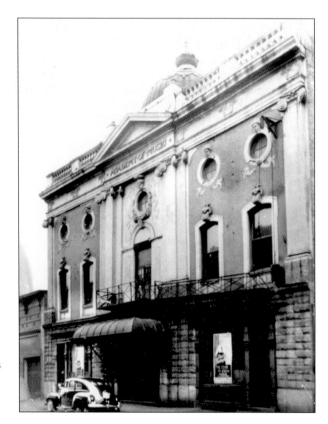

One of downtown Roanoke's earliest ornate structures was the Academy of Music, which was located on Salem Avenue. This is the academy's façade in 1950. The academy was demolished in 1953. (HMHSWV.)

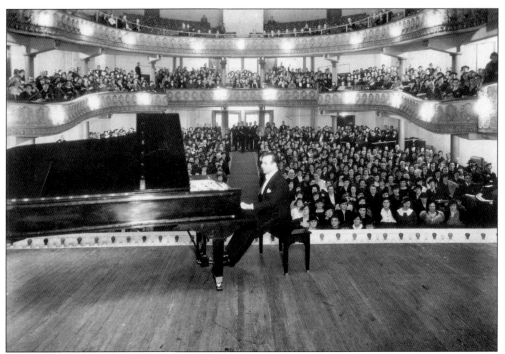

This interior shot of the Academy of Music was taken during a piano concert in 1934. Notice the tiered balconies and the expanse of the performance hall. (HMHSWV.)

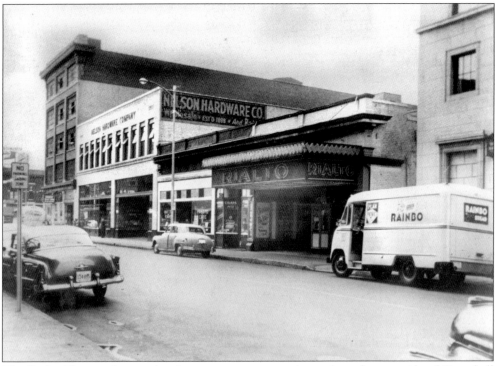

The Rialto Theater, known for showing westerns, was located on the east side of Campbell Avenue, along with Nelson Hardware. This photo is *c*. 1950. (HMHSWV.)

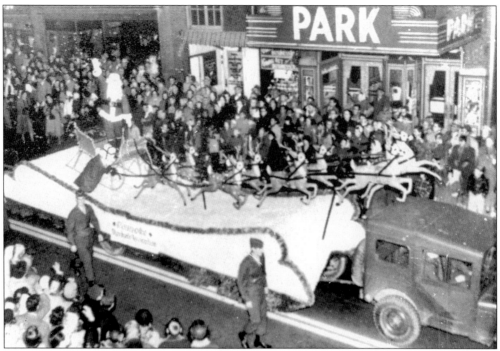

Roanoke's Christmas Parade moves along Jefferson Street in the 1940s. As it does it passes by the marquee of the Park Theater. (HMHSWV.)

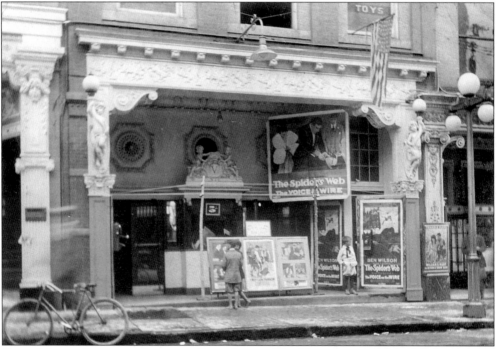

One of the earlier movie houses in Roanoke was The Virginian at 305 S. Jefferson Street, shown in this 1914 image. There were actually three theaters in a row at this time, as the Bijou and Comet Theaters flanked the Virginian. (HMHSWV.)

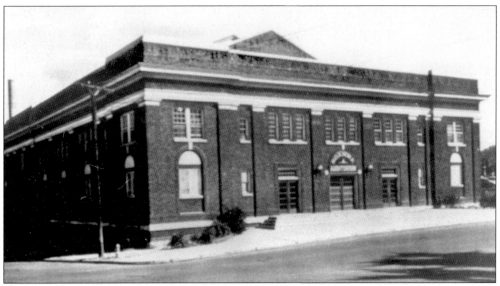

The Roanoke Auditorium, forerunner of the modern Civic Center, was built in 1906 to accommodate shows, circuses, concerts, and other public meetings. Sitting near the Hotel Roanoke, the auditorium was later purchased by the American Legion. It burned in 1957. (HMHSWV.)

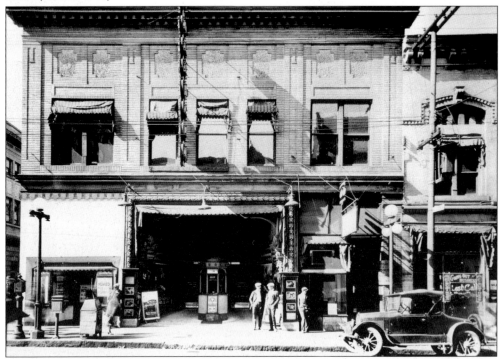

The original American Theater building, shown here, was not built for theatrical purposes when it was constructed in 1902. In 1913, however, it became the first home to Roanoke's American Theater. Between 1911 and 1920, Roanoke's downtown had 11 movie houses. This structure was razed in 1927 to make room for the more grand structure familiar to most Roanokers as The American Theater. (HMHSWV.)

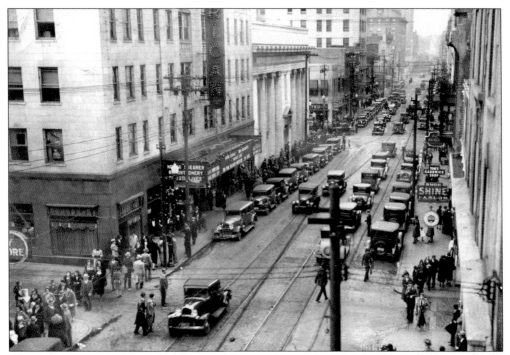

The gala opening for the new American Theater, seen on the left side of Jefferson Street in this image, was on March 26, 1928. The four-story movie house became Roanoke's premier venue for film and entertainment. This image is from 1931. (HMHSWV.)

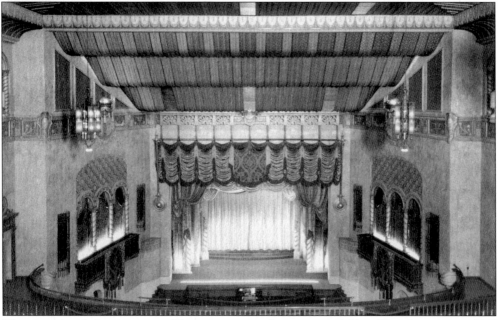

The interior of the American Theater was grand, as was its lobby. The theater cost $1.5 million when it was built in 1927, suggesting the lavish amenities enjoyed by generations of Roanokers. Seating capacity was 2,006. The theater closed in 1970 and was razed in January 1973. (HMHSWV.)

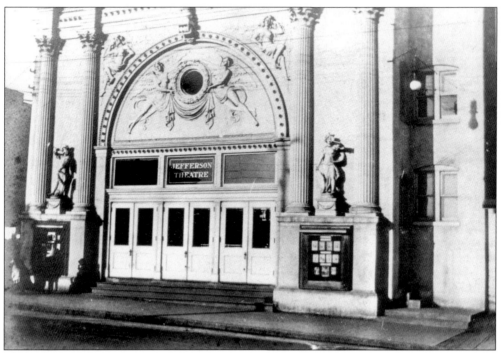

The Jefferson Theater operated for many years downtown. This image shows the theater's exterior as it looked in 1911. (HMHSWV.)

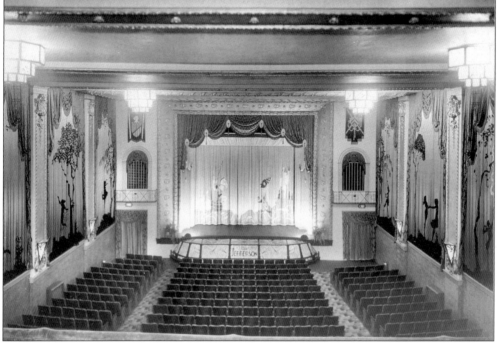

The interior of the Jefferson Theater illustrates the comfortable surroundings afforded customers of Roanoke's early theaters, especially in comparison to the generic look of the modern multi-screen theaters. (HMHSWV.)

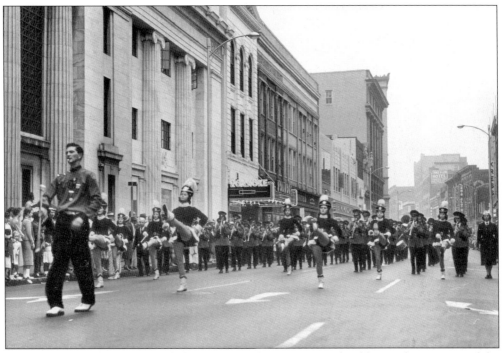

As a parade moves along Campbell Avenue in the 1950s, one should note the marquee of the Roanoke Theater on the left side of this image. (HMHSWV.)

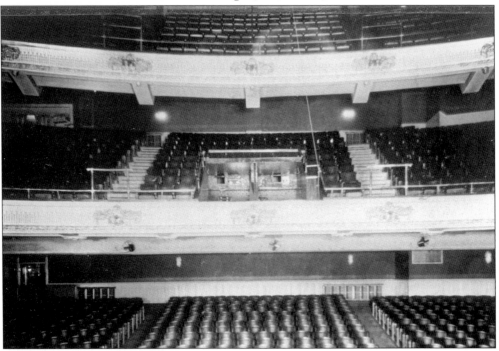

This was the interior of the Roanoke Theater in the 1930s. Although the image does not convey this, the upper balcony was for African-Americans during segregation and had a separate entrance. (HMHSWV.)

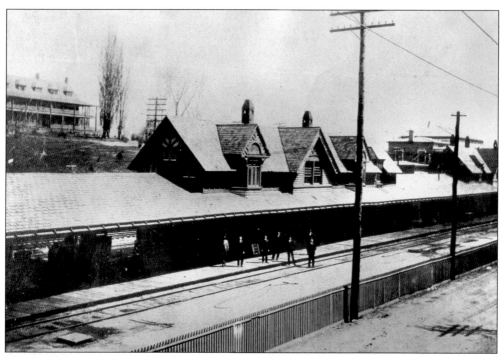

This 1906 photo shows the N&W passenger station that, as shown in previous photographs, sat in the middle of the tracks. If one looks closely, the new depot is under construction in the background to the right, just over the roofline. (HMHSWV.)

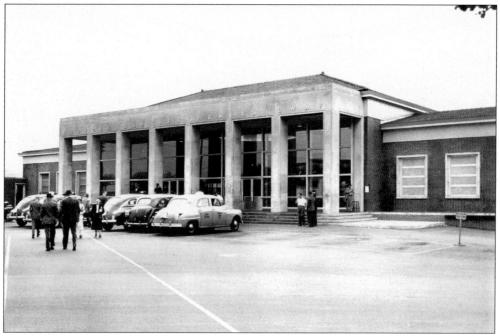

Renowned industrial designer Raymond Lowey remodeled the N&W passenger depot in 1949. This photo was taken in the 1950s. Today, the structure is home to the O. Winston Link Museum, displaying Link's photography of N&W's steam engines. (HMHSWV.)

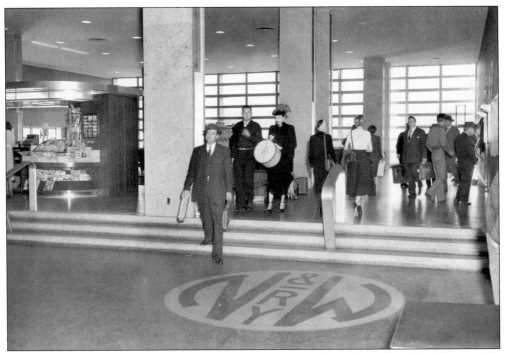

Here is the interior of the N&W passenger station as it looked in the 1950s. Notice the corporate logo on the floor. N&W passenger rail service peaked during World War II and was discontinued in the early 1970s. (HMHSWV.)

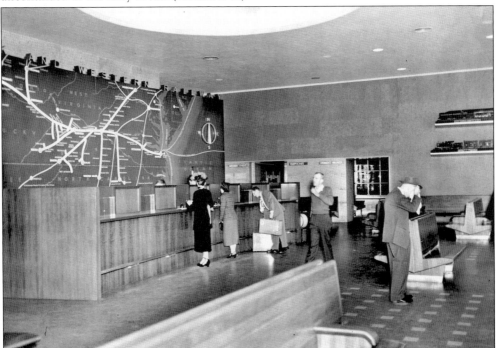

Another interior view of the N&W passenger station shows the ticket area with routes on the wall behind the agents. This photo is also from the 1950s. (HMHSWV.)

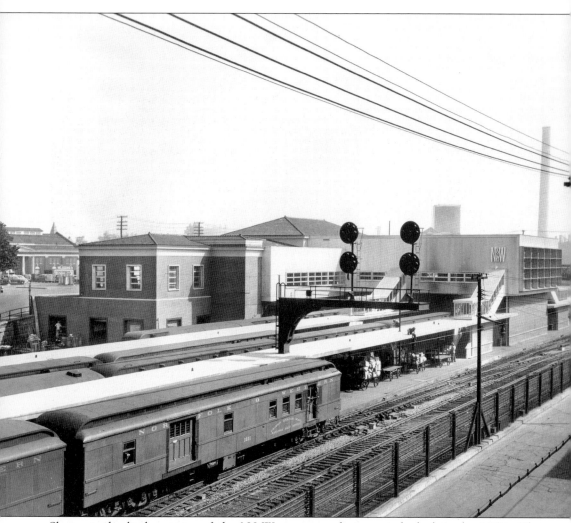

Shown is the back exterior of the N&W passenger depot as it looked in the 1950s. The large portion of the station protruding out across the tracks with covered access to the trains below was removed some years ago. The rail car in the center foreground is a railway post office car. (HMHSWV.)

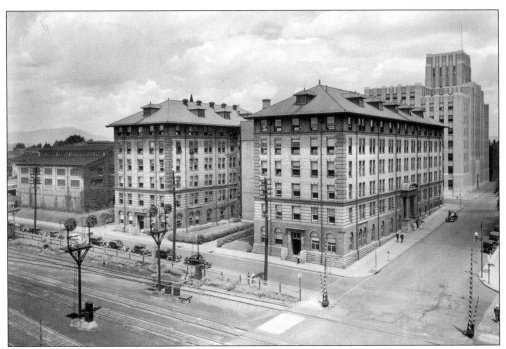

Roanoke's downtown paralleled the development and growth of the N&W Railway for many years. In this 1939 image, one can view the general office buildings of the N&W. The "twins" in the foreground are known today as 8 Jefferson Place and contain upscale apartments, while the taller building behind them is the Roanoke Higher Education Center. (HMHSWV.)

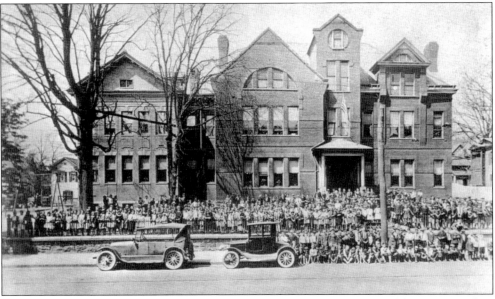

Commerce Street School was one of Roanoke's first public school buildings. Opened in September 1890, the building was originally called the First Ward School and was renamed in 1893. The structure sat where the old Federal Post Office building does today, across from the Municipal Building. The school was razed in May 1929 to make room for the post office. This photo is *c.* 1925. (HMHSWV.)

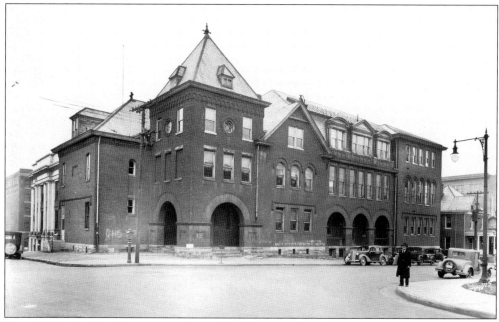

Roanoke High School was erected in 1898 on the corner of Church Avenue and Roanoke Street. It was a high school from 1899 through 1924, after which it served as the school administration building. The building was razed to make room for the new annex to the Municipal Building. (HMHSWV.)

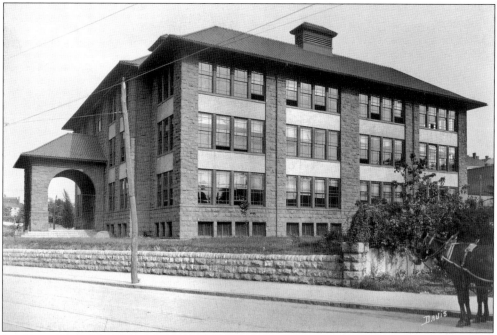

Lee Junior High School was constructed in 1910 for a cost of $90,186. The first session of school opened in September 1912 with a faculty of 24. Originally known as the Central Grammar School, it became Lee Junior High in 1918. It was later razed for construction of the Poff Federal Building. (HMHSWV.)

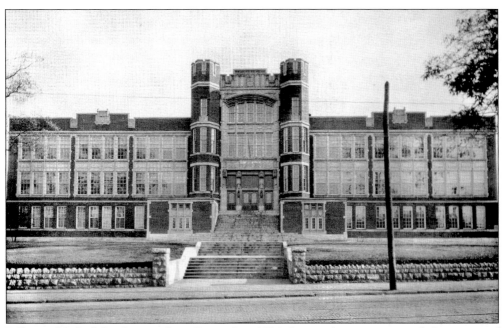

Jefferson High School opened in September 1924, having been constructed for a cost of $550,000. Its enrollment in 1924 was 1,528 with 52 faculty members. Jefferson served as a city high school for nearly 50 years. Today, it is the Jefferson Center and is home to cultural and non-profit agencies. (HMHSWV.)

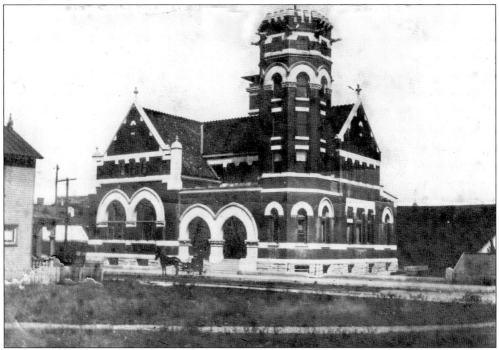

Roanoke's first federally funded post office was elaborate in its architecture and won a national award for its architect. Built before the turn of the last century, it is prominent in the early cityscape photos of Roanoke. (HMHSWV.)

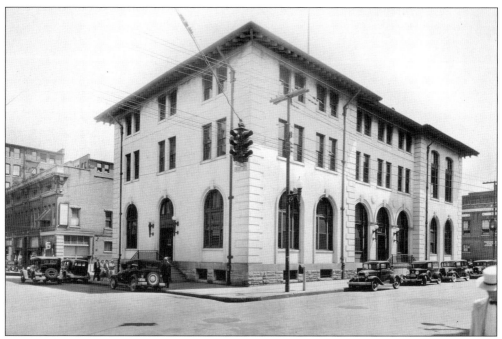

Roanoke's second federally funded post office was constructed on the same site as the first, at the corner of Church Avenue and First Street. The building was erected in 1914 and was replaced in 1933. (HMHSWV.)

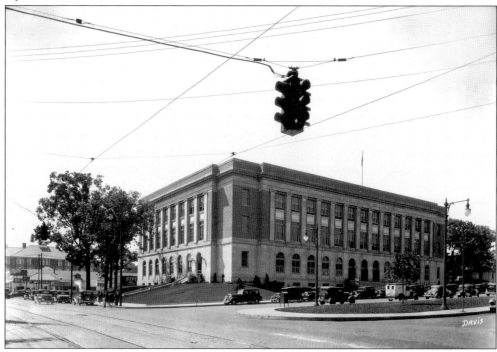

This 1935 image shows Roanoke's United States Post Office and Courthouse Building shortly after it was constructed in 1933. This building today contains offices of the Commonwealth of Virginia. (HMHSWV.)

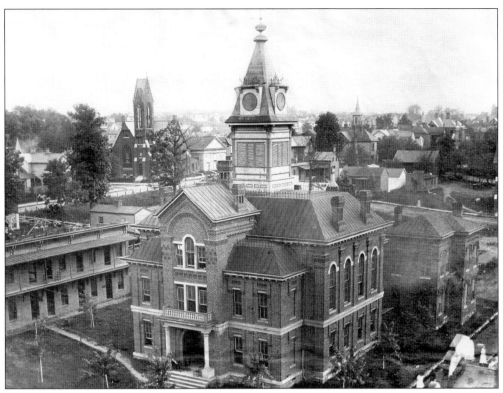

The old Roanoke Courthouse and Jail was an impressive structure in Roanoke's early history. Built in 1887, this was the scene of an 1893 riot in which militia were forced to fire on unruly citizens. Nine people were shot dead. This building was razed to make room for the Municipal Building, erected in 1915. (HMHSWV.)

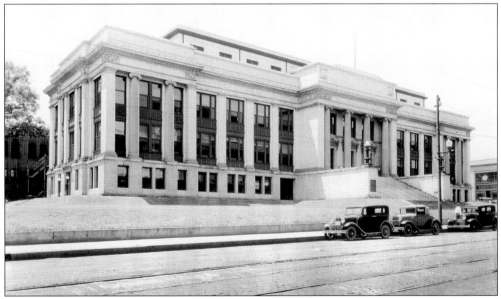

Roanoke's Municipal Building was built in 1915 and serves today as offices for local government. This photo was taken about 1926. (HMHSWV.)

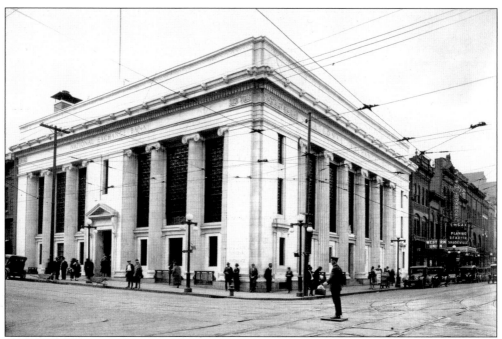

The First National Exchange Bank Building was and is one of Roanoke's most identifiable structures. It was constructed in the early 1920s on the corner of Jefferson Street and Campbell Avenue. This photo was taken about 1930. (HMHSWV.)

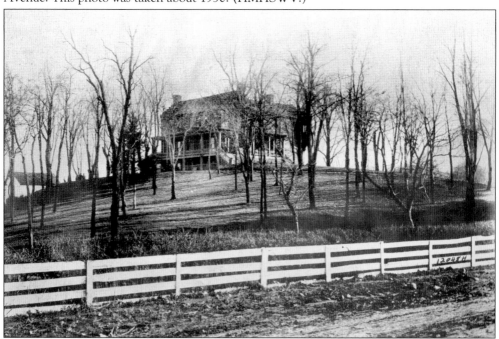

This home, known as "Elmwood," was built around 1830, probably by Thomas Tosh. The estate, which originally consisted of 640 acres, was owned by several people over the course of its existence. The home, along with seven acres, was sold to the city in 1911 and housed the city's first library until it was razed in the early 1950s. This image is c. 1890. (HMHSWV.)

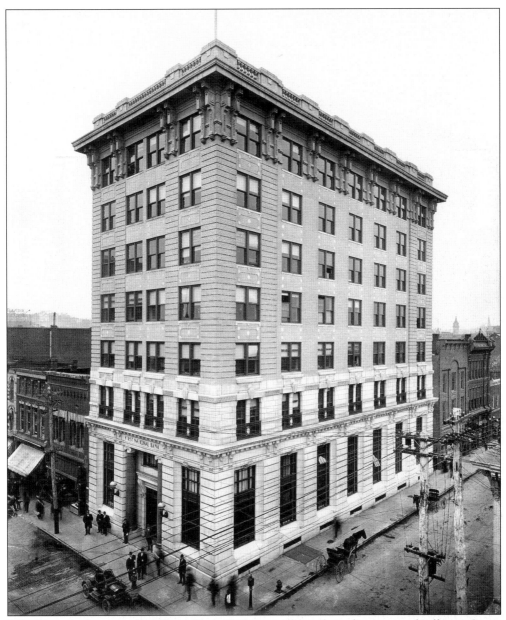

What many refer to as the Liberty Trust Building still stands at the corner of Jefferson Street and Salem Avenue. This image shows the building in 1910. Note the horse-drawn carriage at the curb. (HMHSWV.)

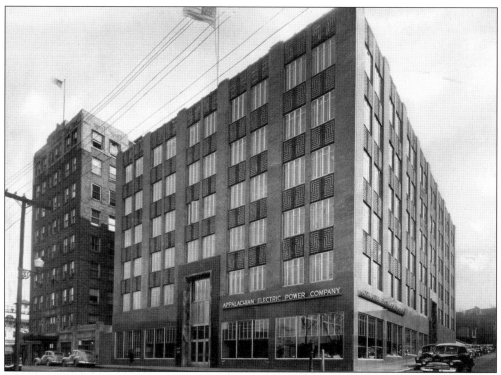

The Appalachian Power Co. and the Medical Arts Building (to the left) are the subjects of this 1955 photograph. (HMHSWV.)

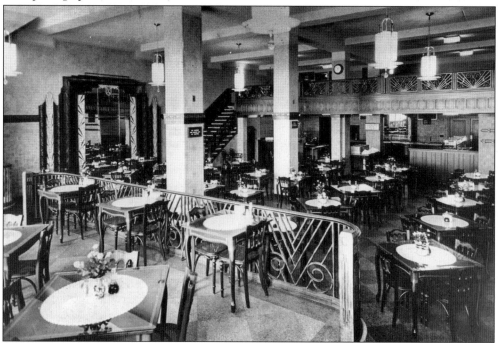

This 1942 image shows the interior of the S&W Cafeteria that was located at 412 S. Jefferson Street. (HMHSWV.)

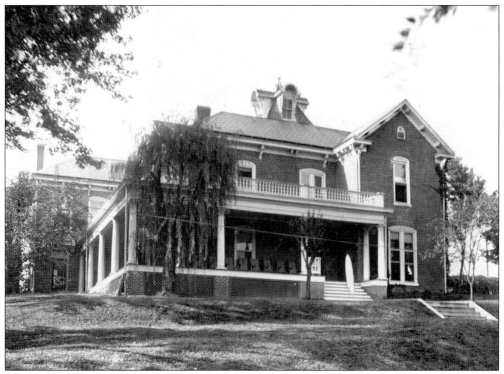

This undated photograph shows the original downtown home of the Shenandoah Club. (HMHSWV.)

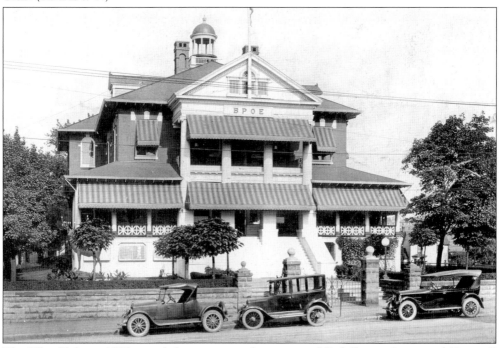

The Elks Club, c. 1930, stood downtown at the corner of S. Jefferson Street and Tazewell Avenue until it was razed in 1973. (HMHSWV.)

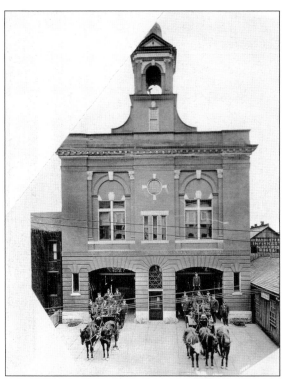

Roanoke's No. 1 Firehouse does not look much different today than it appeared in this *c.* 1907 image, though the fire suppression equipment has certainly changed! (HMHSWV.)

Roanoke Fire Department Station No. 3, on Sixth Street, SW, is manned and ready in this 1910 photograph. (HMHSWV.)

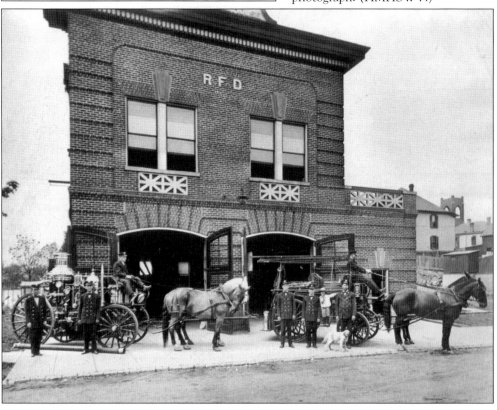

WDBJ television and radio station was located for many years at this building on Twelfth Street and Kirk Avenue. WDBJ Television went on the air on October 3, 1955. (HMHSWV.)

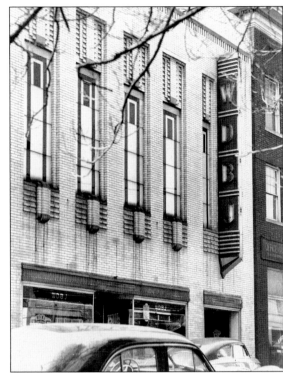

The Young Women's Christian Association (YWCA) had their own building complete with a cafeteria. This image is *c.* 1930. (HMHSWV.)

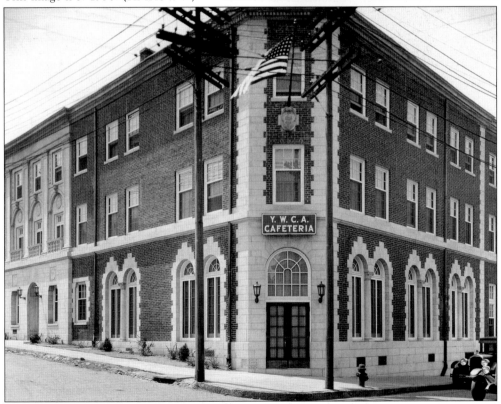

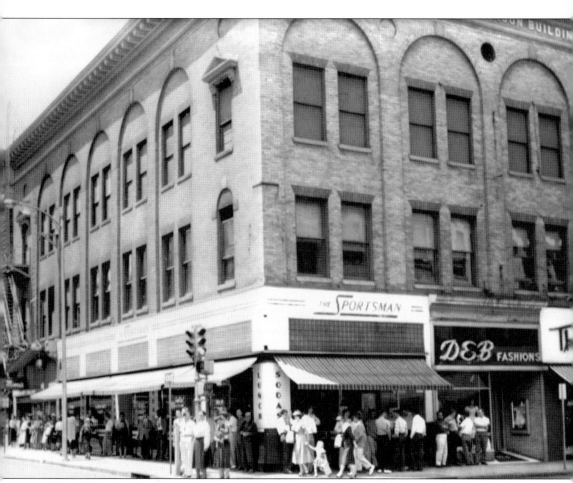

The Williamson Building, shown c. 1951, was erected in 1907 at the corner of Church Avenue and Jefferson Street and housed many tenants during its lifetime. Many Roanokers will remember the Sportsman, DEB Fashions, and Thom McCann Shoes. The Sportsman downstairs had a lunch counter. The second floor had a poolroom, and the top floor contained a bowling alley. The building was razed in 1977. (HMHSWV.)

# *Three*

# HOTELS, HOSPITALS, AND MERCHANTS

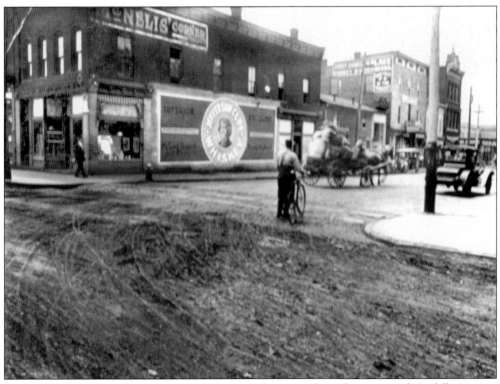

In this 1915 photograph, McNelis and Byrnes Saloon stands at the corner of Norfolk Avenue and First Street, SE. (HMHSWV.)

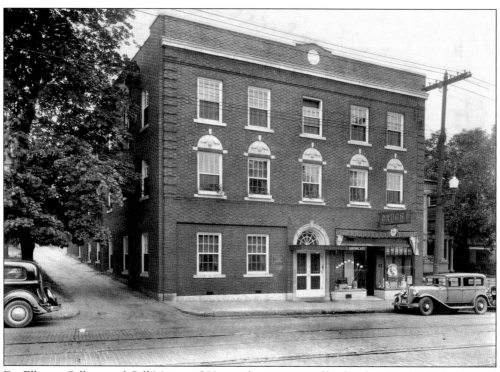

Dr. Elbyrne Gill erected Gill Memorial Hospital in memory of his brother, Brill Gill. It formally opened on Jefferson Street on July 30, 1926. This image is c. 1930. (HMHSWV.)

Physicians at Gill Memorial Eye, Ear, and Throat Hospital pose in front of the building in 1928. (HMHSWV.)

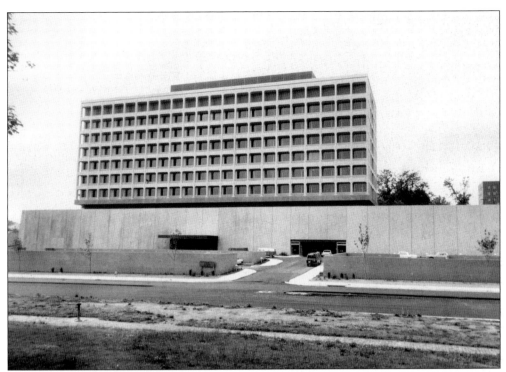

Community Hospital opened in the fall of 1967 with 400 beds. The total construction cost was $9 million. (HMHSWV.)

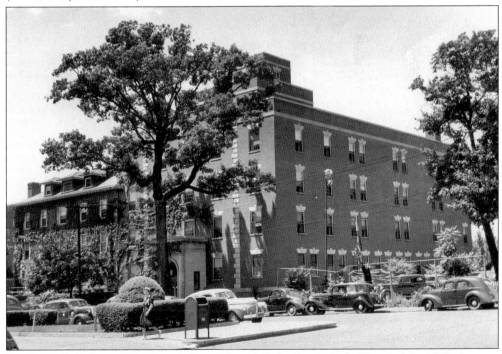

Dr. Sparrell Gale and Dr. Joseph Lewis founded the Lewis-Gale Hospital in 1909. It went through several additions while located downtown. This photo is c. 1950. (HMHSWV.)

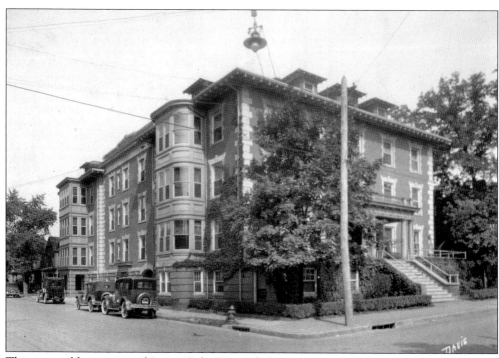
This is an older picture of Lewis-Gale Hospital showing its original façade. This photo was taken in 1925. (HMHSWV.)

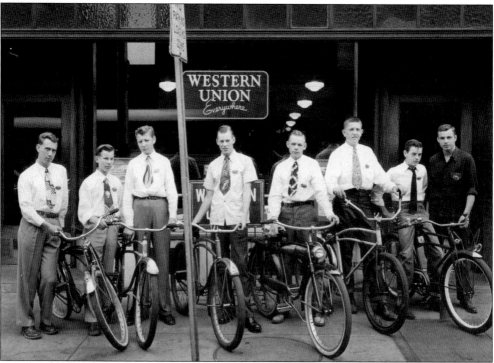
Western Union messengers are ready to deliver as they pose in front of the Western Union office at 9 S. Jefferson Street. (HMHSWV.)

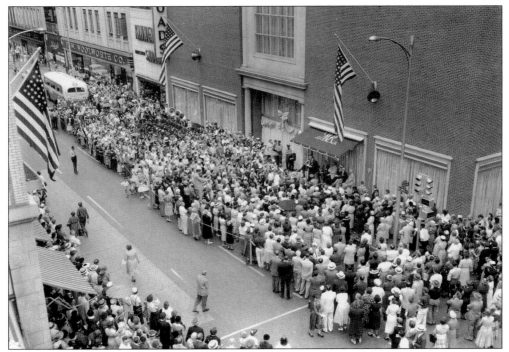

A crowd gathers in front of Miller and Rhoades Department Store for Opening Day in 1962. (HMHSWV.)

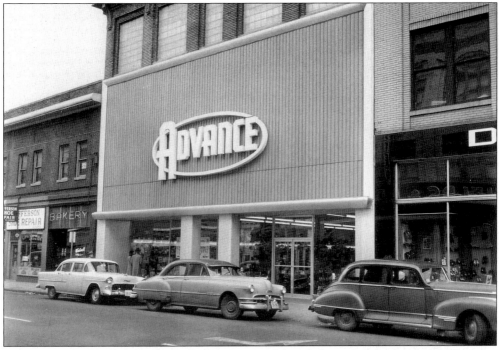

In 1932 Arthur Taubman came from Baltimore and founded two Advance stores in Roanoke, one of which was downtown. Taubman's Advance stores became one of Roanoke's best business success stories. This image is c. 1955. (HMHSWV.)

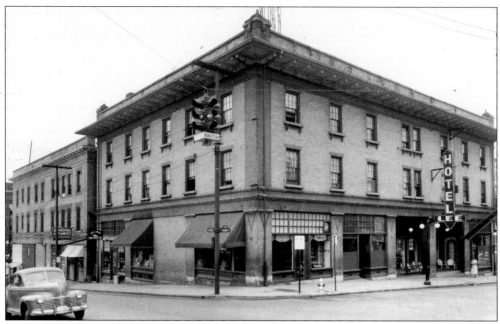

The Lee Hotel contained a saloon and other businesses as tenants when it first opened in 1890. Gentleman boarders could take table privileges for $13–15 per month at that time. The building, at the corner of Second Street and Salem Avenue, was later used by the Salvation Army. (HMHSWV.)

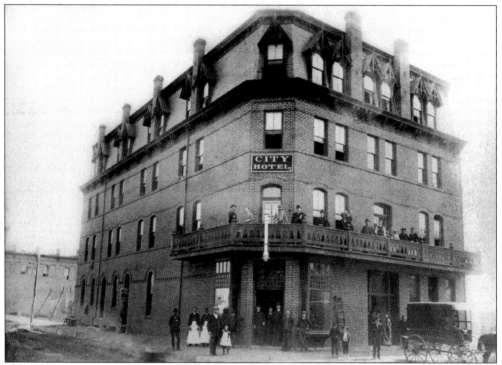

Edward E. Didier built the four-story City Hotel in 1886 at the southeast corner of Jefferson Street and Salem Avenue. In later years it was known as the Bear Building. (HMHSWV.)

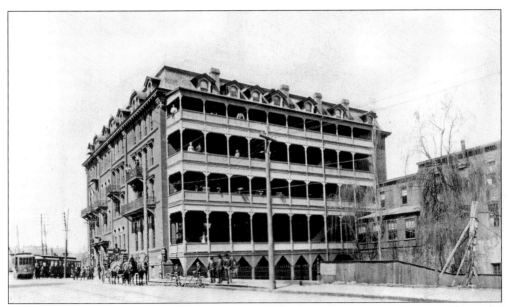

The Ponce de Leon Hotel looked much different when it was first built. This image shows the back of the hotel as it appeared around 1890. (HMHSWV.)

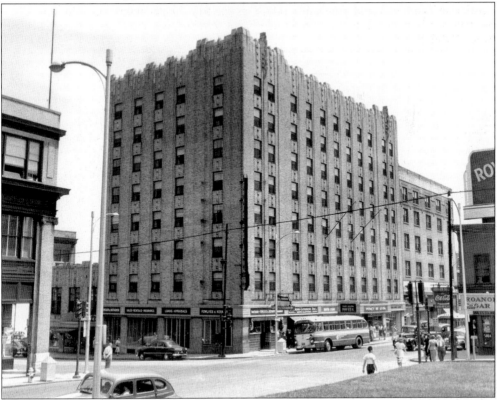

The more familiar façade of the Ponce de Leon Hotel can be seen here. No longer a hotel, it is now an office building. This 1951 image also shows the Roanoke Cigar Co. on the opposite corner. (HMHSWV.)

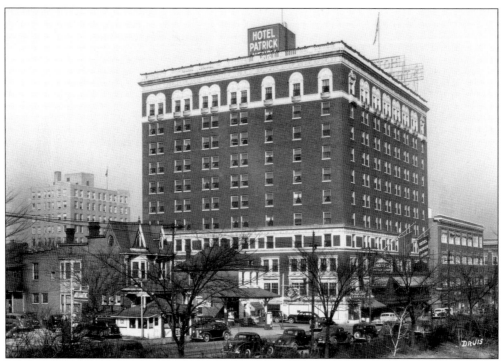

The Patrick Henry Hotel on Jefferson Street has been a historic fixture along one of downtown's busiest streets. This image is *c*. 1950. (HMHSWV.)

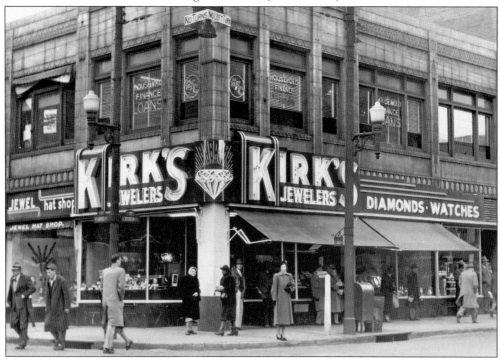

Kirk's Jewelers was one of many fine jewelry stores once located downtown. Kirk's was located at 110 S. Jefferson Street. This photo is dated 1955. (HMHSWV.)

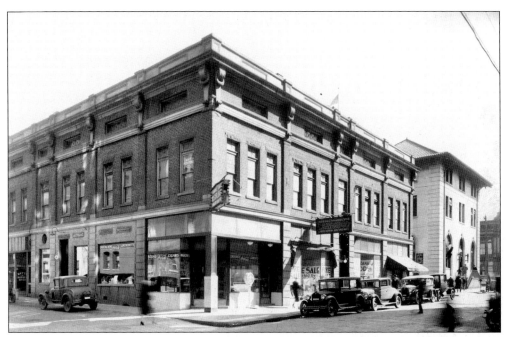

The Horton Building, located on the southeast corner of Henry Street and Church Avenue, contained a number of enterprises at the time this 1920 photo was taken, including L. Savage Co. ("Ladies Hosiery Our Specialty"), Art Painting Co., and Watts Barbershop. The federal post office is in the background. (HMHSWV.)

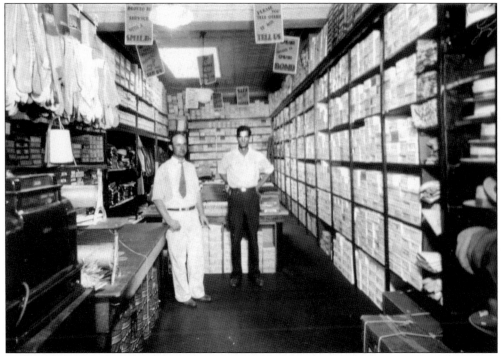

Isadore "Ike" Cohen and Ralph Payne are inside the old Army-Navy Store at 112 First Street, SE. The photo is undated. (HMHSWV.)

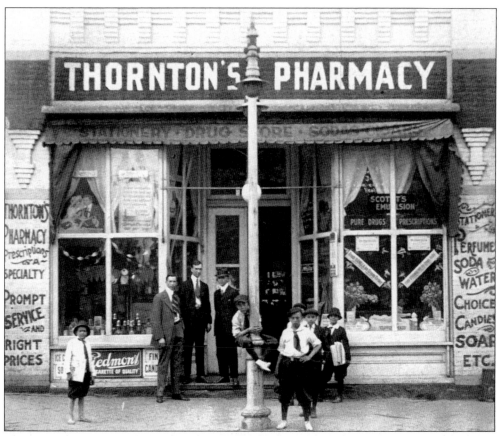

Thorton's Pharmacy was located in the 300 block of First Street in earlier years. This *c.* 1930 image shows newsboys on the sidewalk. Ads in the store window include Piedmont Cigarettes, Scott's Emulsion, and "Fresh Vanilla Ice Cream Today." (HMHSWV.)

Fisburn Brothers Tobacco Factory, which opened in 1885, was located at the corner of Center Avenue and Second Street. This photo was taken around 1910. (HMHSWV.)

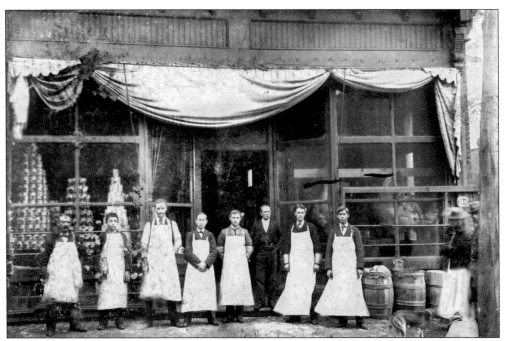

This c. 1890s image shows the Catogani Grocery Store that was located across from the city market building. Mr. Catogani is the one without the clerk's apron. The grocer moved his business to Salem Avenue in 1898. (HMHSWV.)

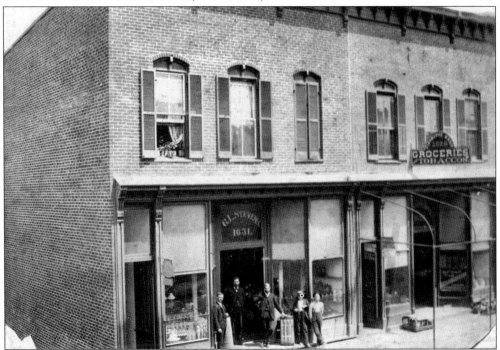

S.L. Stevens and Fishburne Brothers Grocery were next-door neighbors in the 1600 block of Salem Avenue between First and Second Streets. This photo was taken sometime around 1900. (HMHSWV.)

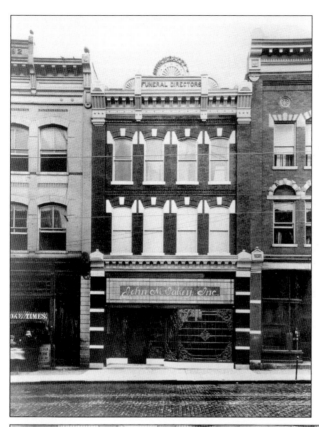

John M. Oakey was 15 when he moved with his parents from Lynchburg to the Roanoke Valley in 1854. In 1866, after serving in the Civil War, he opened a small shop making coffins by hand. The fruit of his efforts eventually became the John M. Oakey Funeral Service, still in operation and owned by his descendants. This image shows the funeral home at its early location, 124 Campbell Avenue, c. 1910. (HMHSWV.)

S.H. Heironimus Co. is having its January White Sale in this c. 1910 photograph. The store moved to this location at the northeast corner of Campbell Avenue and First Street in 1898. In 1956, Heironimus moved to larger quarters at Jefferson and Church. (HMHSWV.)

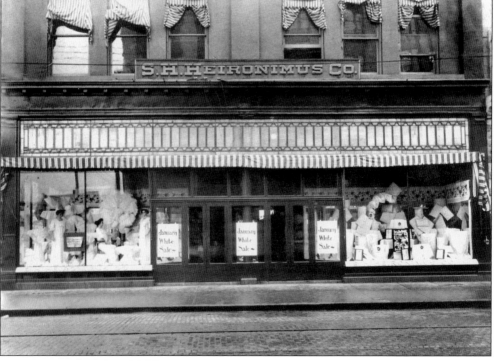

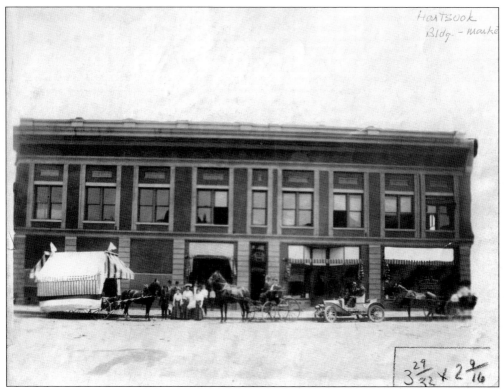

$3\frac{29}{32} \times 2\frac{9}{16}$

The Hartsook Building on the city market is shown as it appeared in 1915. (HMHSWV.)

The J.M. Martseller Marble Works is on the left side and the Bright and Krebbs Dry Goods Store on the right in this building erected in 1897. The door in the middle led up to the residence of Roy Kinsey Sr. This image from 1907 shows that "downtown living" is not a 21st-century idea. (HMHSWV.)

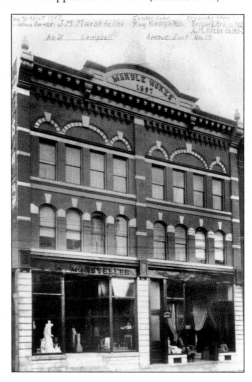

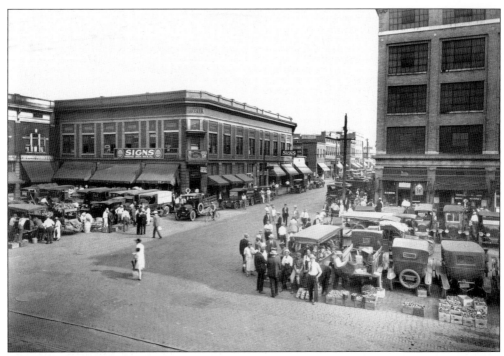

This 1925 George W. Davis photo shows Market Square; note the brick streets. The Hartsook Building is the center structure. (HMHSWV.)

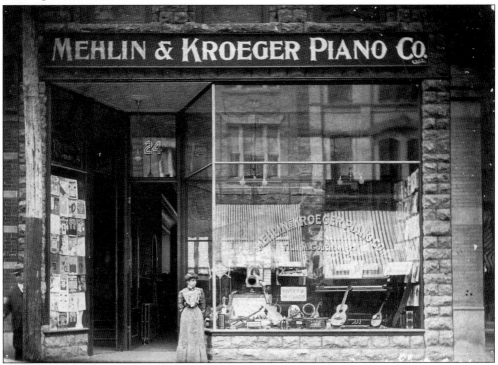

The Mehlin and Kroeger Piano Co. was located at 24 Campbell Avenue, shown here, at the turn of the century. A few years later, in 1902, its address was 12 Salem Avenue. (HMHSWV.)

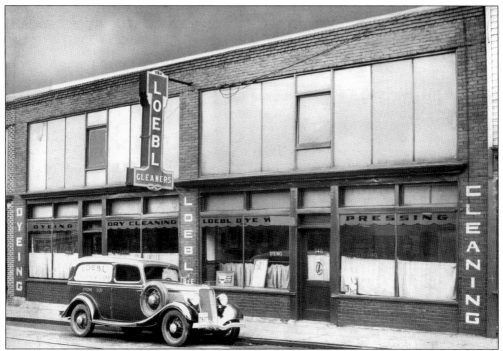

Loebel Cleaners was located at 346 Salem Avenue for many years. It advertised "dyeing, cleaning, and pressing" services. This image was made about 1935. (HMHSWV.)

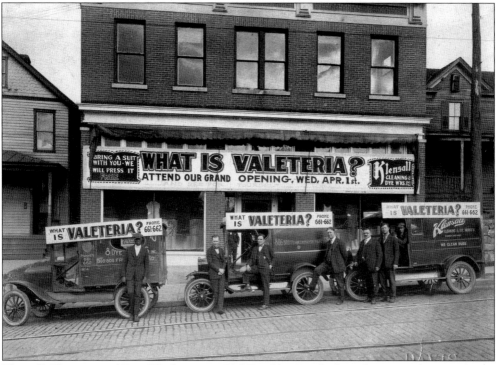

Klensall Cleaning and Dye Works was at 806 Franklin Road when this 1924 photograph was taken. (HMHSWV.)

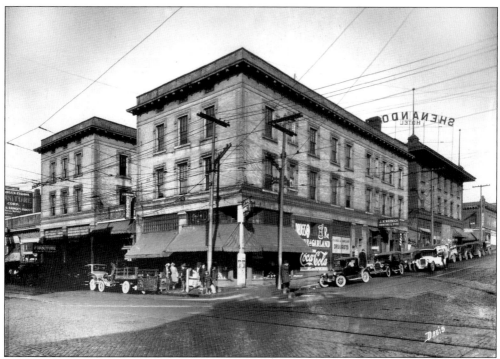

This 1925 image shows the Shenandoah Hotel, Clore and Garland Drugstore, J.H. Waynick Furniture and Stoves, and the J.C. Parrish Furniture Co. (HMHSWV.)

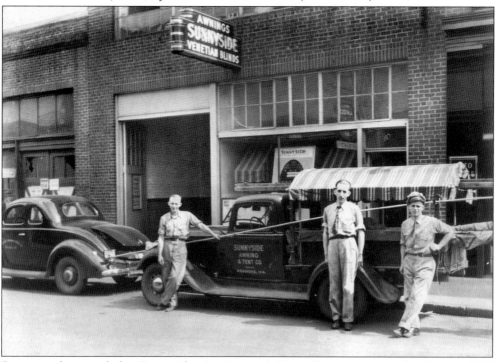

Some employees of the Sunnyside Awning and Tent Co. are posing for this *c.* 1940 picture. (HMHSWV.)

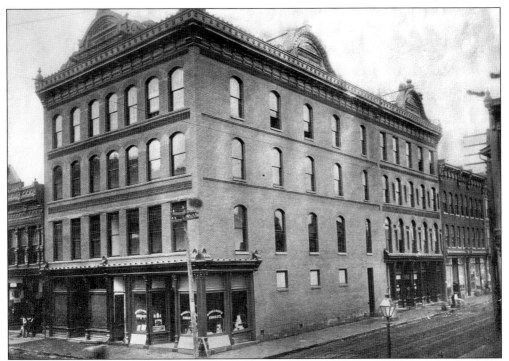

This undated image shows the Massie and Martin Drug Store at the southwest corner of Salem Avenue and Second Street. (HMHSWV.)

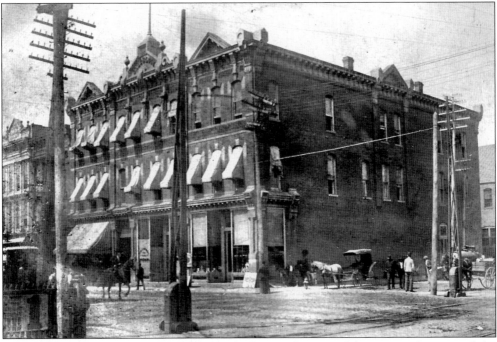

The Gale Building contained businesses and offices at the turn of the century. It occupied the corner of Second Street and Campbell Avenue, and in 1915 its major tenant was the Greene Brothers Cigar Co. (HMHSWV.)

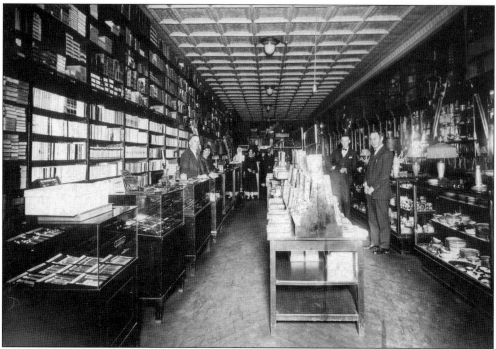

Here is the interior of the Roanoke Book and Stationary Co. that was for many years located at 15 W. Campbell Avenue. (HMHSWV.)

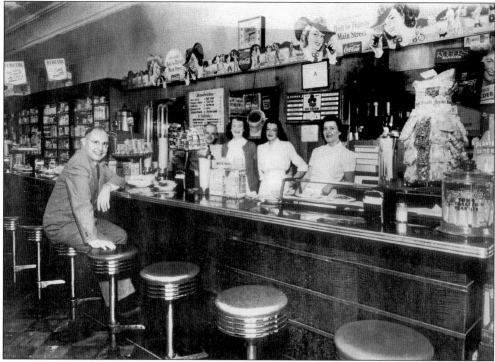

Mr. Garland is seen seated inside Garland's Drug Store at the northwest corner of Salem Avenue and Jefferson Street; no date is given for the photo. (HMHSWV.)

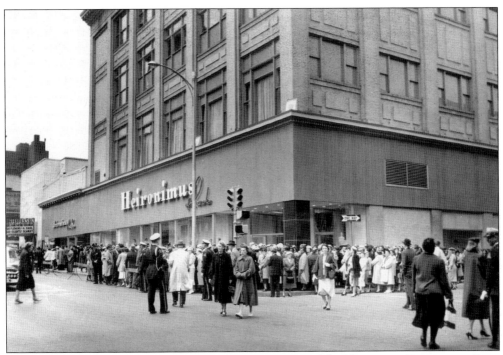

This is believed to be the opening day for the new quarters of the Heironimus Department Store in 1956. Note the Jefferson Theater's marquee advertises the film *Slightly Scarlet*. (HMHSWV.)

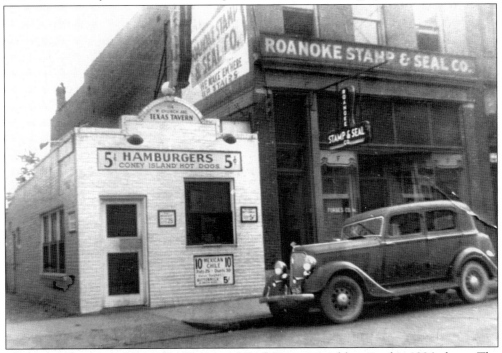

The Texas Tavern and Roanoke Stamp and Seal Co. are neighbors in this 1936 photo. The Texas Tavern, a mainstay of the downtown community, opened its doors on February 13, 1930. (HMHSWV.)

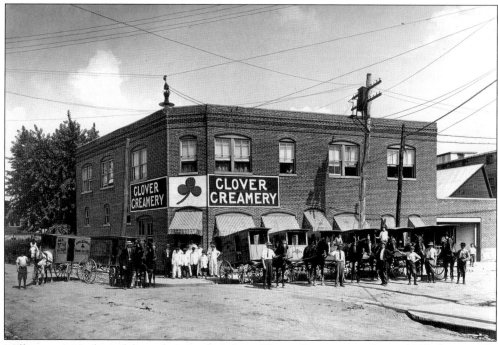

Milkmen are ready to deliver their product from Clover Creamery in this *c.* 1915 photograph. Clover Creamery was one of Roanoke's leading creameries for many years. (HMHSWV.)

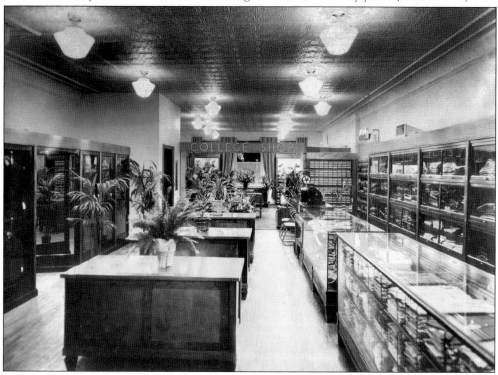

Here is the interior of the Glenn-Minnich clothier for men as it looked in the 1940s. Note the "College Shop" at the back. (HMHSWV.)

This streetscape of the 100 block of W. Campbell Avenue shows Glenn-Minnich, Bush and Hancock Clothiers, and Sea Foods Restaurant in the 1940s. Glenn-Minnich moved to this location in 1935, having originally opened in 1913 in a smaller store. S.M. Glenn was president, and C.B. Minnich was vice-president and general manager. (HMHSWV.)

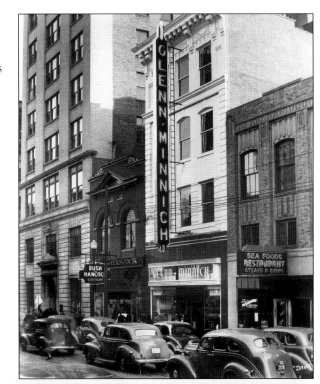

This is the crowd that showed up for the grand opening of the new and relocated Smartwear-Irving Saks store on April 19, 1948. (HMHSWV.)

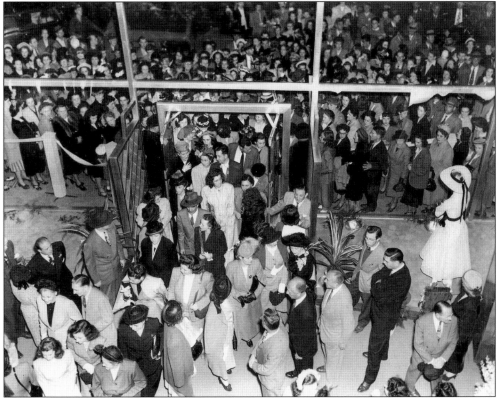

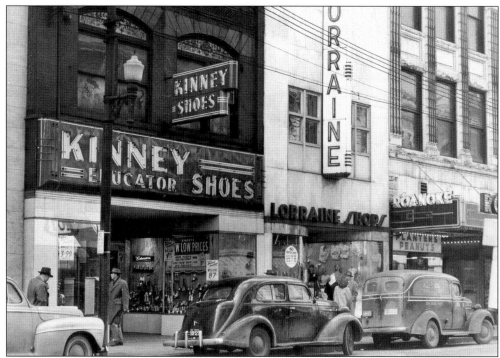

Another streetscape shows some more downtown merchants—Kinney Shoes; Lorraine Shops, which opened in 1938; and the Roanoke Theater. The photo is *c.* 1940s. (HMHSWV.)

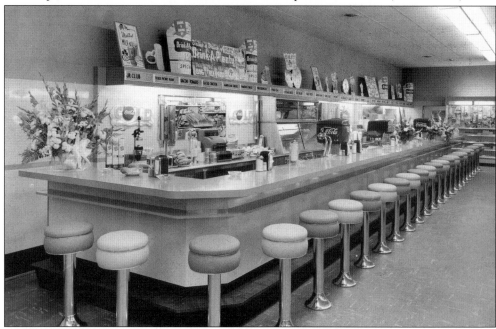

Joseph H. Milan and Abraham Milan opened Milan Brothers Cigar Store on the southeast corner of Jefferson Street and Salem Avenue in 1912. After World War II, the store, now operated by the brothers' sons, moved to 106 S. Jefferson Street and had the soda counter, as shown above. (HMHSWV.)

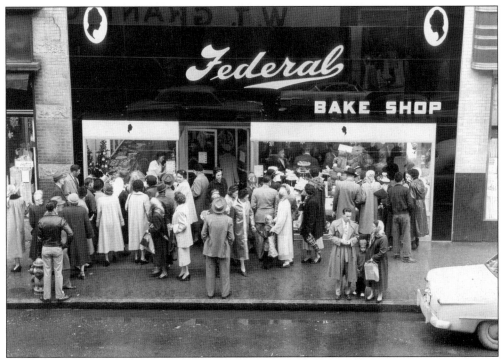

The Federal Bake Shop was one of many bakeries that used to serve downtown; it was located at 22 Campbell Avenue in this *c.* 1960 photo. (HMHSWV.)

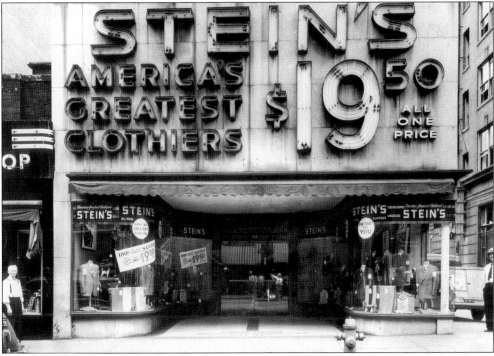

Stein's Menswear, which boasted "America's Greatest Clothiers—$19.50, All One Price," was at 216 S. Jefferson Street in this 1950s image. (HMHSWV.)

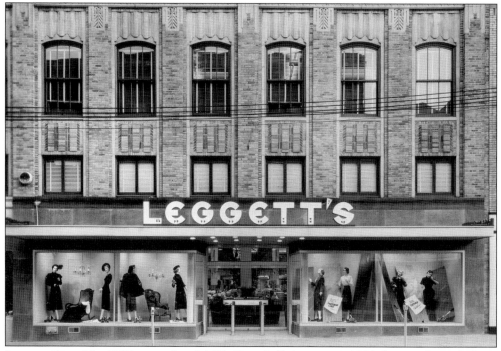

Leggetts Store No. 7323 opened at 24 W. Campbell Avenue in 1931, having formerly been Montgomery-Wards. Here is the store's front in the 1950s. (HMHSWV.)

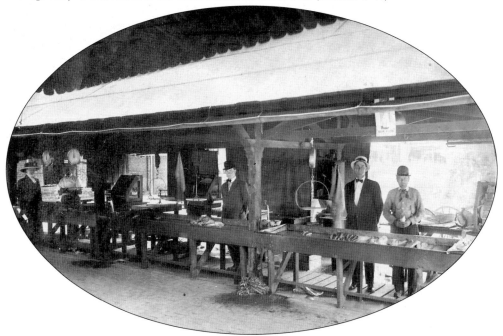

Compared to the developing downtown of the 1940s and 1950s with large department stores and specialty shops, these guys (and gal) had it simpler. Here is Mrs. R.F. Henry, Mr. R.F. Henry, N.C. Cassell, H.M. Cassell and a Mr. Dickerson are pictured at their fish stall on the city market in 1910. (HMHSWV.)

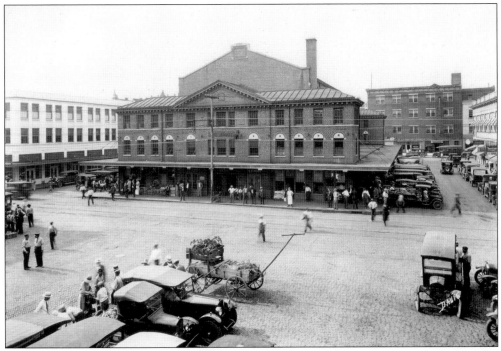

Market Square is shown with the city market building in the center as it looked in the 1930s. (HMHSWV.)

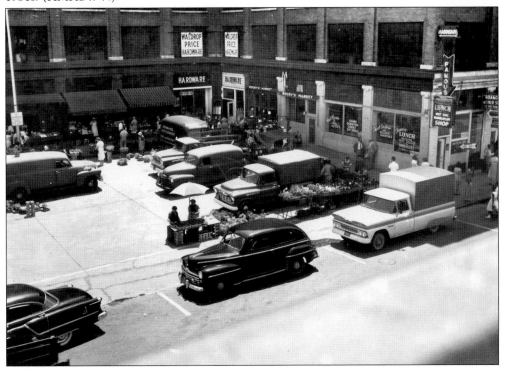

Another view of the city market around 1960 shows the Famous Lunch, Rocky's Market, Waldrop Price Hardware, and, of course, the Roanoke Wiener Stand. (HMHSWV.)

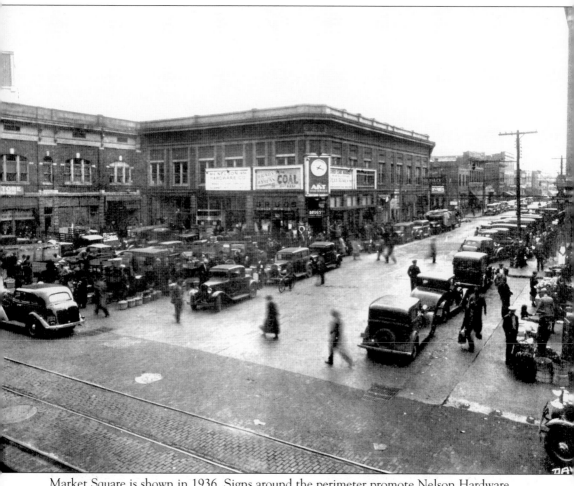

Market Square is shown in 1936. Signs around the perimeter promote Nelson Hardware and Turner Drugstore. The Hartsook Building, prominent in all market views, is in the center. (HMHSWV.)

# *Four*
# EVENTS

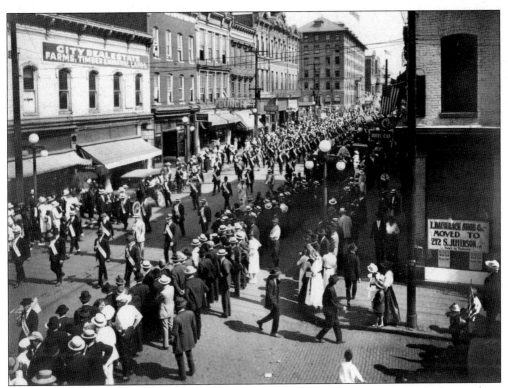

During World War I, Americans were encouraged to support the troops through the purchase of Liberty Bonds. Here is Roanoke's contribution to that effort—the 1918 Liberty Bonds Parade. The parade is moving along Jefferson Street. (HMHSWV.)

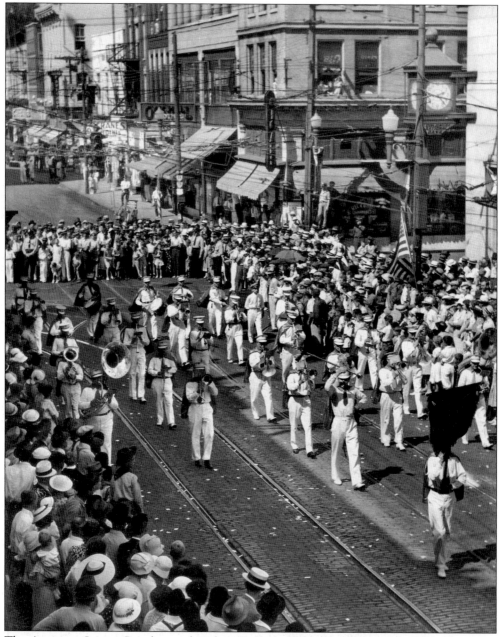

The American Legion Parade marches down Jefferson Street on August 25, 1936. The group seen here is the N&W Railway Co. band. (HMHSWV.)

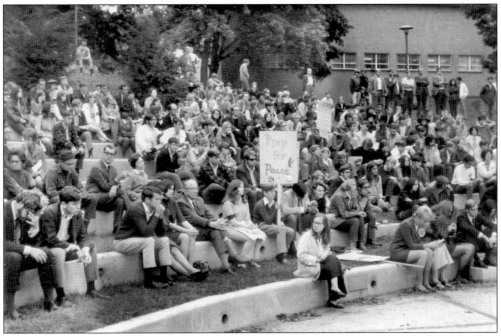

Not all events in downtown Roanoke's history have been celebrations. This gathering in Elmwood Park occurred in October 1969 to protest the Vietnam War. (HMHSWV.)

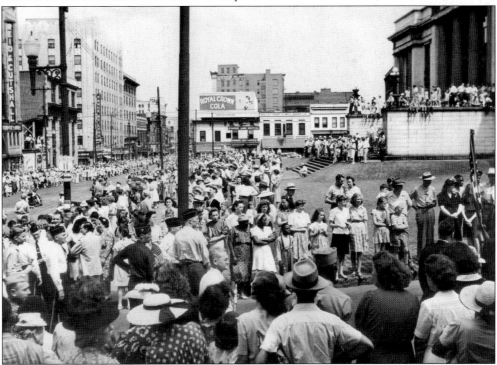

In 1945, Roanoke, like most communities in America, celebrated victory in World War II. This image shows a crowd gathered near the Municipal Building to watch downtown's Victory Parade. (HMHSWV.)

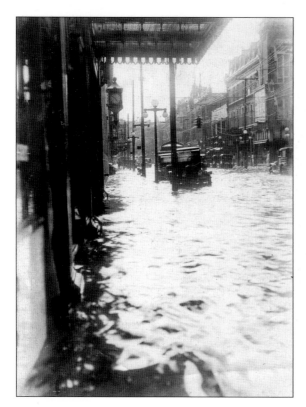

Not all events were planned and organized; sometimes Mother Nature provided one of her own. Flooding has always plagued downtown, and here is a scene of one such event in 1927. (HMHSWV.)

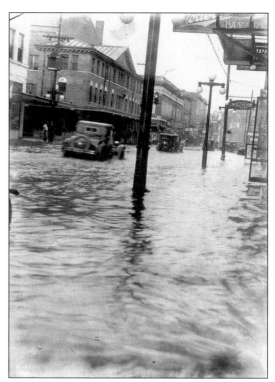

Here is another shot of the same flood shown in the above image. (HMHSWV.)

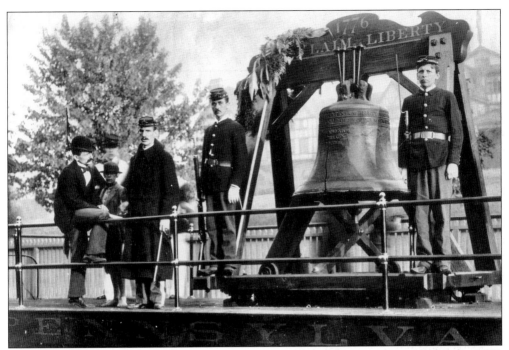

The famous Liberty Bell passed through Roanoke on Sunday morning, October 6, 1895. Hundreds of Roanokers came for a view at 6:30 a.m. The bell was being transported by rail and made a stop long enough for Roanokers to see one's of America's more famous historical treasures. (HMHSWV.)

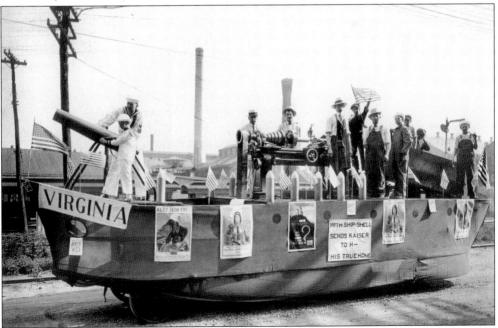

Here is a float for one of Roanoke's parades during World War I. The banner reads, "With ship and shell send Kaiser to H——, His True Home." The float was promoting the sale of war savings stamps. (HMHSWV.)

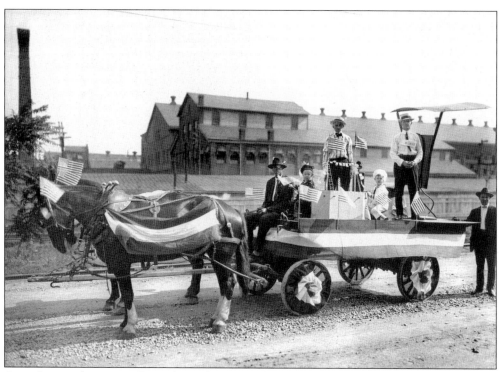

As with an earlier image, Roanoke's Liberty Bonds Parade in 1918 invited all kinds of entries. Here is a float waiting to go as its attendants pose for a picture. (HMHSWV.)

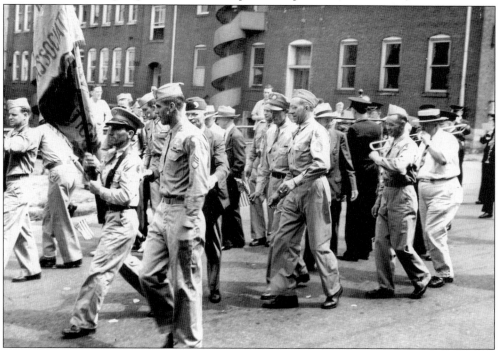

Veterans of World Wars I and II march in Roanoke's Victory Day Celebration Parade on August 15, 1945. (HMHSWV.)

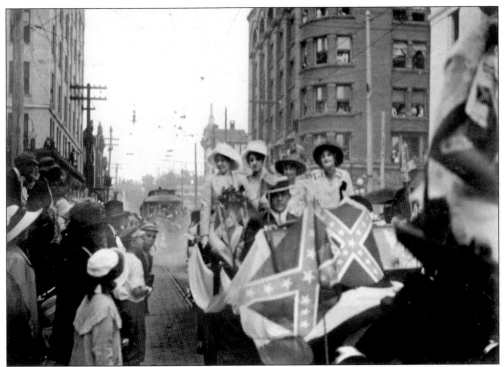

In September 1913, Roanoke hosted a Confederate Veterans Reunion. As part of the event, there was, of course, a parade. Here are some of the participants in the parade. (HMHSWV.)

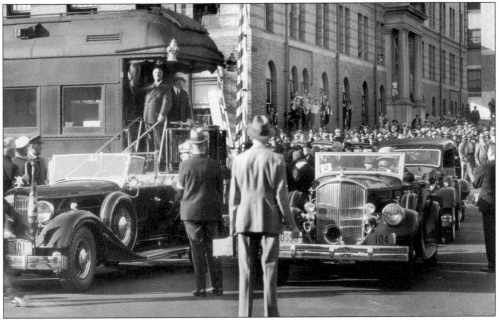

On October 9, 1934, President Franklin D. Roosevelt visited the valley to dedicate the new Veterans Administration Hospital. En route by train, the President pauses for a moment as he passes through downtown. The old N&W general office building is in the background. (HMHSWV.)

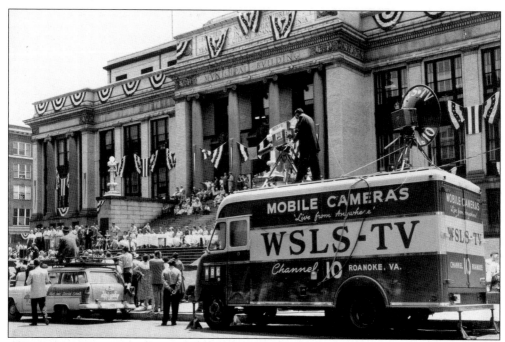

The flag-draped Municipal Building is the backdrop for this photo showing a portion of Roanoke's Diamond Jubilee festivities in 1957. The Jubilee honored Roanoke's 75th anniversary. (HMHSWV.)

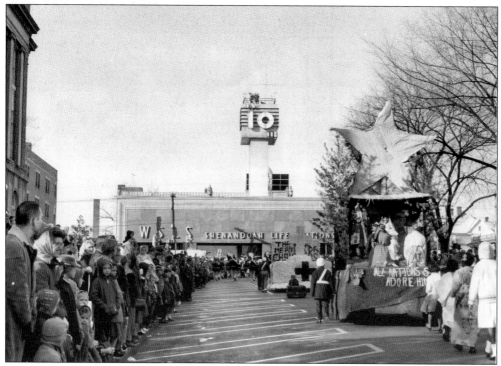

The Diamond Jubilee Parade passes in front of the old post office, now the Commonwealth Building, and the local NBC television affiliate, WSLS Channel 10. (HMHSWV.)

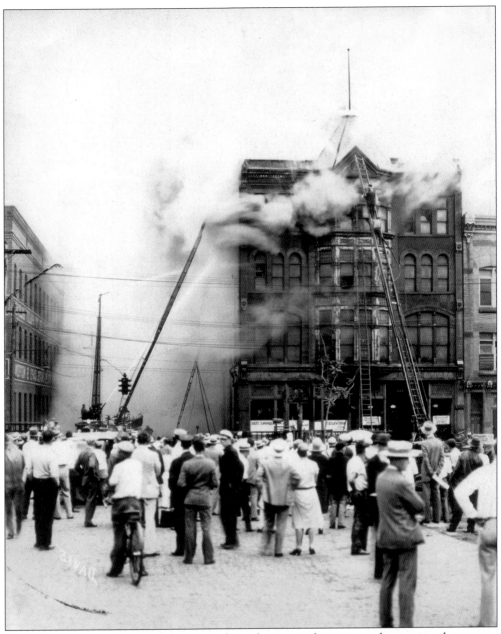

Parades, protests, and jubilees were not the only events that attracted attention downtown. Here the Philip-Levy store is afire in 1930. The structure, at the corner of Salem Avenue and Third Street, consumed 30 carloads of furniture. One historian wrote, "At 3:30 p.m. the walls fell in with a roar heard all over downtown." (HMHSWV.)

On October 6, 1923, the cornerstone was laid for the new Jefferson High School. (HMHSWV.)

Claudine Woodrum is crowned Queen of the Carnival in this photo taken during Roanoke's carnival on July 26, 1900. The grandstand is in front of the Watt, Rettew, and Clay store in the 100 block of Salem Avenue. (HMHSWV.)

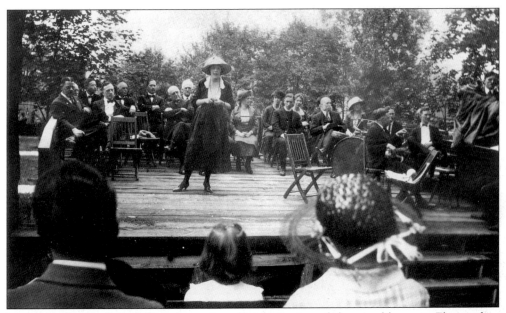

Ms. Sarah Caldwell Butler speaks at the official opening of the city library in Elmwood in 1921. (HMHSWV.)

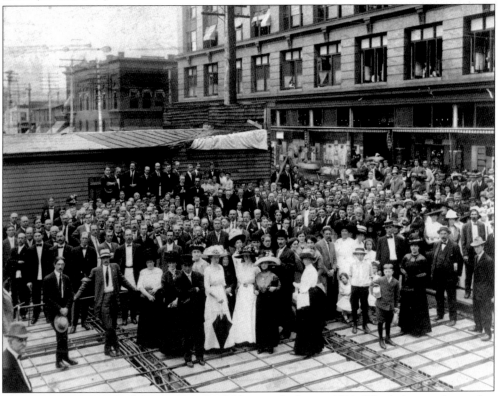

The cornerstone was laid for the Lakeland Masonic Lodge in 1911. The lodge was located at Kirk Avenue and First Street. The large building in the background was later occupied by S.H. Heironimus. (HMHSWV.)

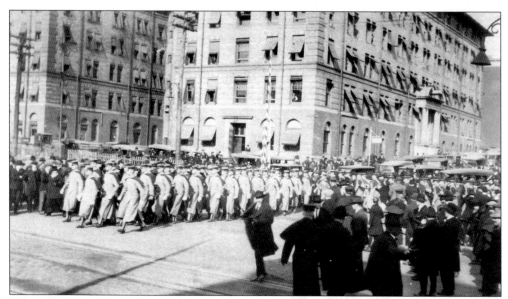

The cadets from the Virginia Military Institute (VMI) march in Roanoke's Thanksgiving Day parade in this 1929 image. VMI played Virginia Polytechnic Institute (VPI) at Victory Stadium on Thanksgiving for many years. The big game was preceded by a parade with the cadets from the train station to the stadium. (HMHSWV.)

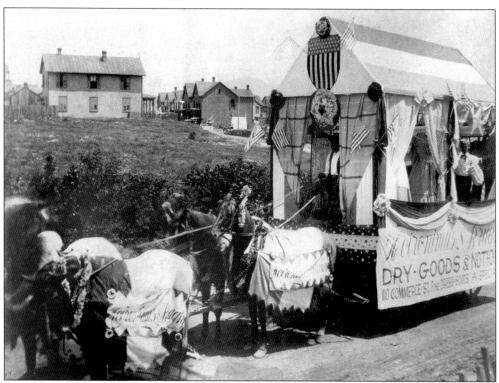

One of Roanoke's earliest special events was its Decennial Parade held in 1892, celebrating the city's 10-year anniversary. Here is the Heironimus and Brugh store float. (HMHSWV.)

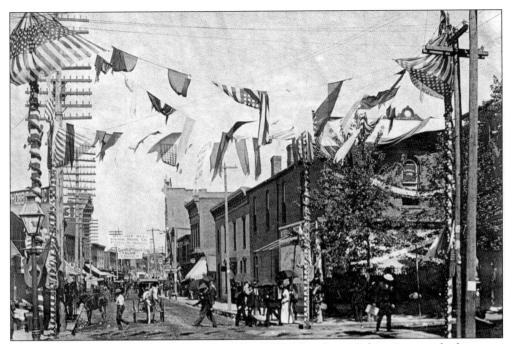

The Decennial Parade took place on June 18, 1892. This shows Salem Avenue, looking east from Second Street, decked out for the festivities. (HMHSWV.)

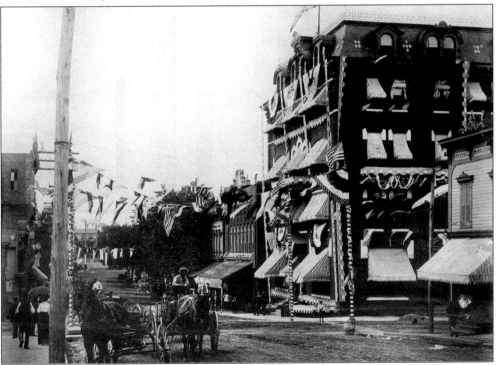

The Decennial celebration was citywide and not just confined to a parade route. Here is Second Street looking north from Campbell Avenue. The flag-draped structure is the Ponce de Leon Hotel. (HMHSWV.)

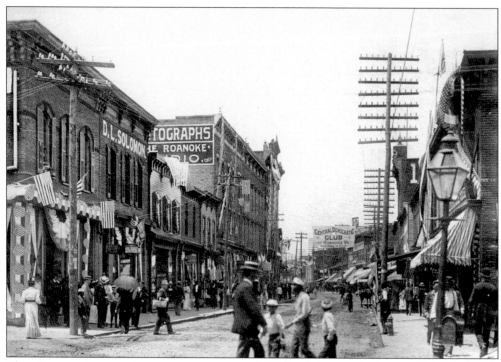

This Decennial photo shows the intersection of Salem Avenue and First (Henry) Street, looking west. Signs in view include the YMCA, and D.L. Solomon. The middle banner reads "Central Democratic Club of Roanoke." In the bottom right is a small postal box attached to a street lamppost. (HMHSWV.)

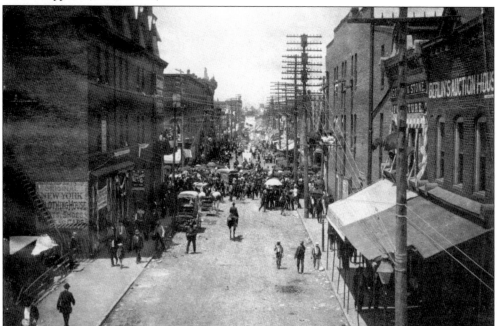

The Decennial Parade moves down Salem Avenue toward the intersection with Jefferson Street. (HMHSWV.)

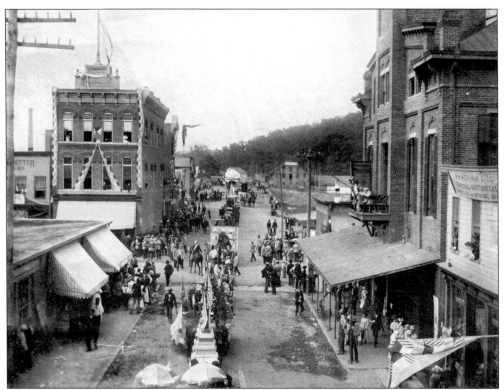

The Decennial Parade passes along Salem Avenue to First Street, moving by the city market building. (HMHSWV.)

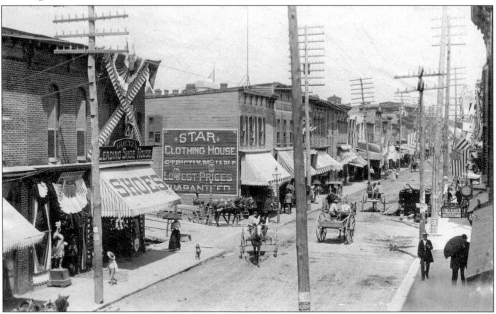

Here is a different perspective of the same 1892 parade. This view looks east from Salem Avenue at First Street. Signs in view include Goetz's Leading Shoe House, Star Clothing House, and YMCA, open 10 a.m.–10 p.m. (HMHSWV.)

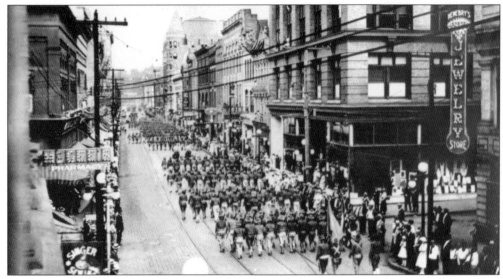

A World War I parade, probably held in 1918, moves along Campbell Avenue, crossing First Street. (HMHSWV.)

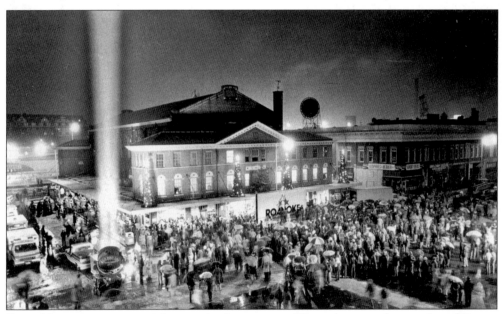

One of the more recent special events in the memory of Roanokers was the opening of Center in the Square in 1983. Representing the renewal of and reinvestment in downtown, the Center is home to Mill Mountain Theater and various museums today. (HMHSWV.)

# *Five*
# STREETSCAPES

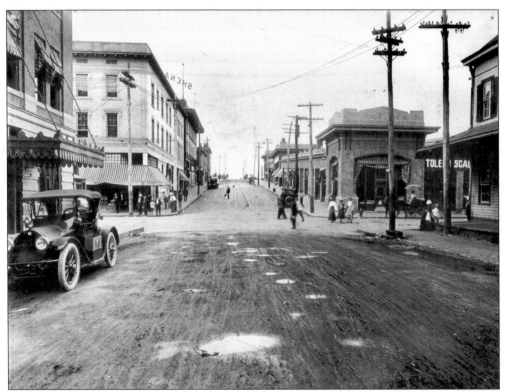

Randolph Street, now Williamson Road, is shown in 1915 near the intersection with Campbell Avenue. The Randolph Street market building is on the right. Note the mud holes in the dirt street have been recently filled. (HMHSWV.)

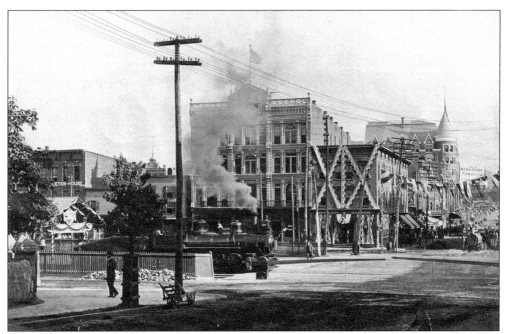

Here is the intersection of Norfolk Avenue and Jefferson Street in 1892. The Continental Hotel, the prominent building in the center with the flag on top, was built in 1889 and was touted as having the most handsome front in all of Roanoke. The hotel was later known as the St. James. It was razed in 1955 to make room for the Hunter Viaduct. (HMHSWV.)

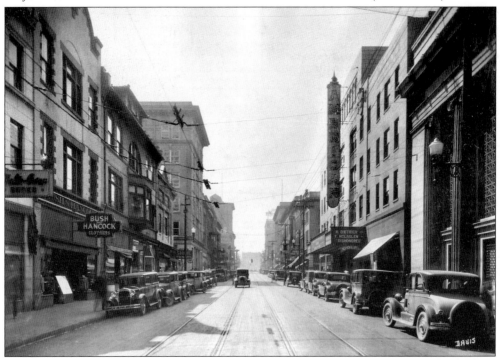

This view of Jefferson Street looking south from Campbell Avenue is from 1931. The building on the right is the American Theater and to the left is Bush-Hancock Clothiers. (HMHSWV.)

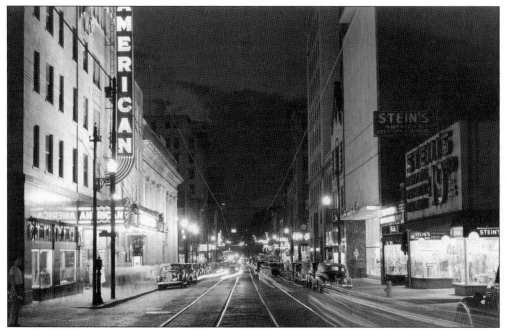

If you were downtown at night in the 1940s, this is how Jefferson Street looking north from Kirk Avenue would appear. The lighted marquee of the American Theater causes the streetcar tracks to glimmer like ribbons against the brick-paved street. (HMHSWV.)

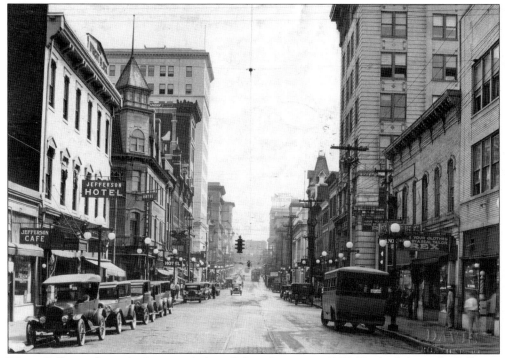

This is Jefferson Street looking south from Salem Avenue in 1927. To the left are the Jefferson Hotel and Colonial Hotel; the building on the right is marked "Rex the Tailor." (HMHSWV.)

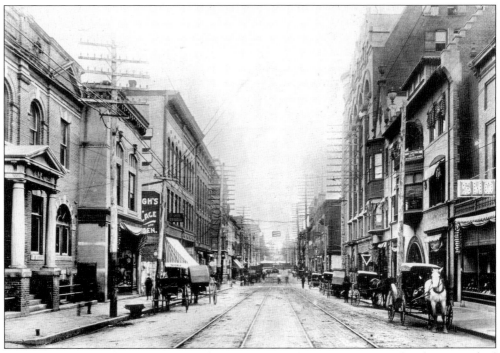

Around of the turn of the last century, the intersection of Jefferson Street and Kirk Avenue had almost as many four-legged visitors as two-legged. (HMHSWV.)

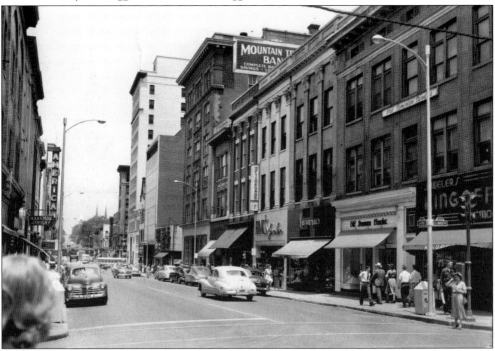

Fifty years later, the streetscape of Jefferson had definitely changed. Here is a view looking north from Church Avenue. Stores fronting Jefferson Street include Old Dominion Candies, Lazarus, Fink's Jewelers, Harrison Jewelry, and the American Theater. (HMHSWV.)

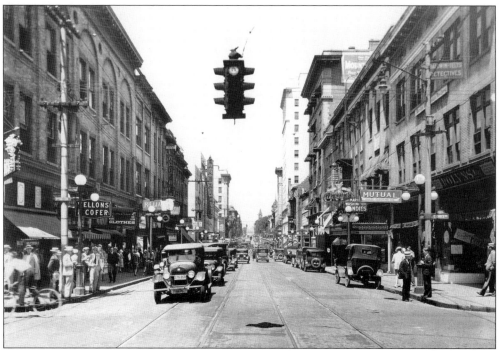

This image of Jefferson Street looks north around 1920. Businesses in view include Baldwin-Felts Detective Agency, Mutual Clothing Co., and Martha Washington Candies. (HMHSWV.)

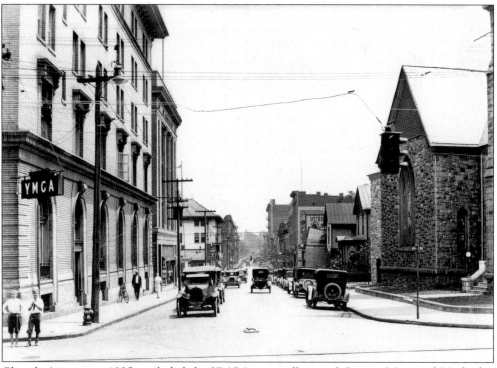

Church Avenue, *c.* 1925, included the YMCA, post office, and Greene Memorial Methodist Church. This view looks east from Second Street. (HMHSWV.)

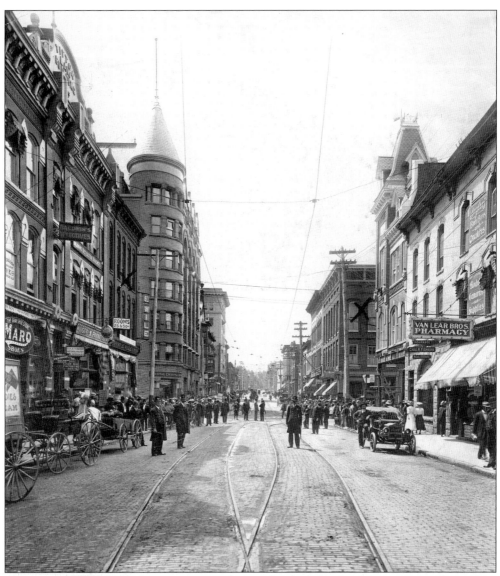

This is Jefferson Street looking south around 1900. On the left side of the image are Tipton Law Building, St. Lawrence Hotel, George F. Payne Co., and the National Exchange Bank, also known as the Terry Building. On the right is Van Lear Brothers Pharmacy. A policeman is centered between the streetcar tracks. (HMHSWV.)

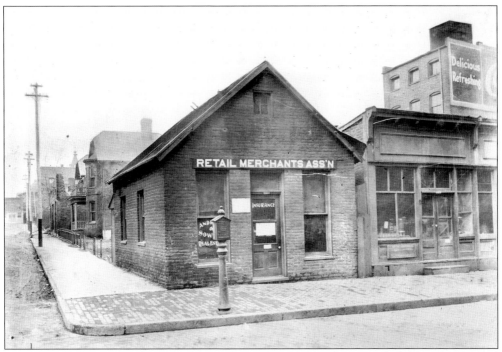

The Retail Merchants Association occupied the corner of First Street and Kirk Avenue around 1890. (HMHSWV.)

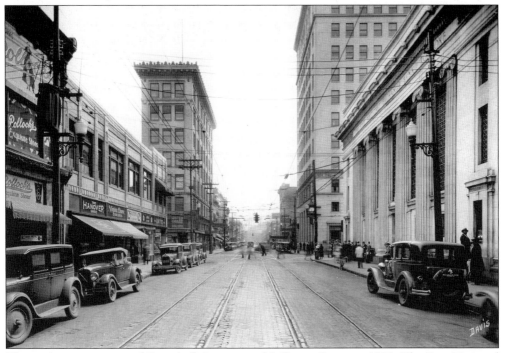

This is the intersection of Campbell Avenue and Jefferson Street in 1931. The First National Exchange Bank Building is to the right with the Colonial American Bank Building in the right background. (HMHSWV.)

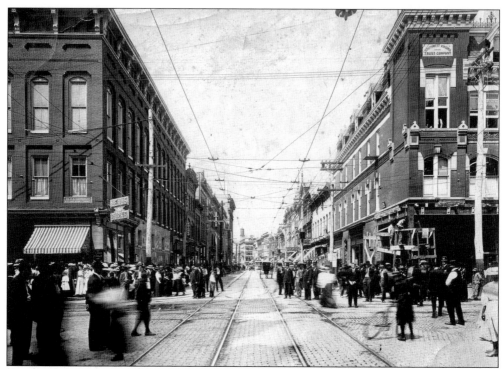

This 1912 photograph shows the intersection of Campbell Avenue and Jefferson Street looking west. (HMHSWV.)

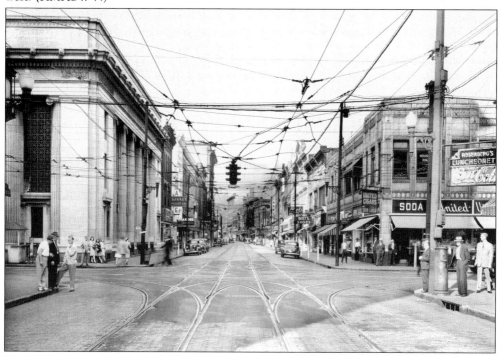

Here is the same intersection, Jefferson Street and Campbell Avenue, in 1949. It is still as busy as it was nearly four decades earlier. (HMHSWV.)

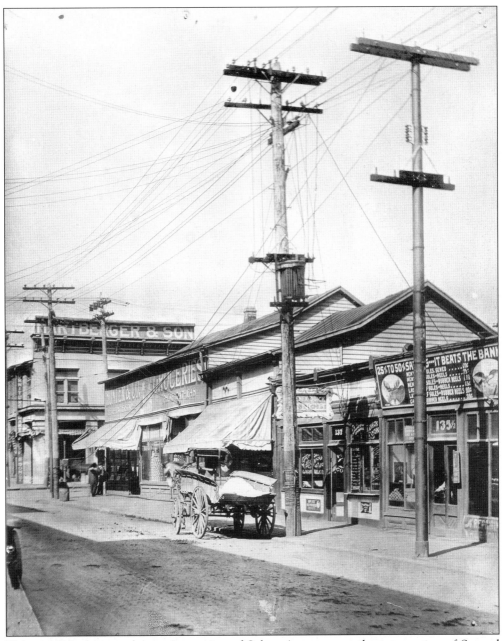

This c. 1915 photograph contains a view of Salem Avenue near the intersection of Second Street. (HMHSWV.)

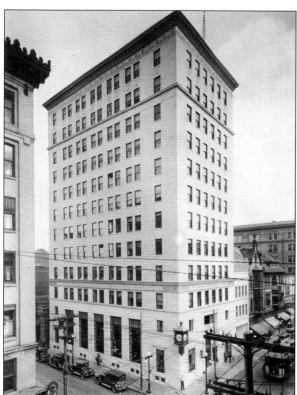

One of the most prominent structures at the intersection of Jefferson Street and Campbell Avenue is the former Colonial American Bank Building. Perhaps the most notable element of the building is the clock that protrudes at the corner. This image is from the early 1920s. (HMHSWV.)

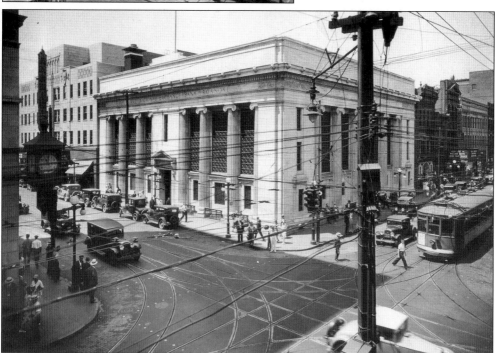

Across from the Colonial American Bank is the First National Exchange Bank. Note the streetcar grid running through the intersection. (HMHSWV.)

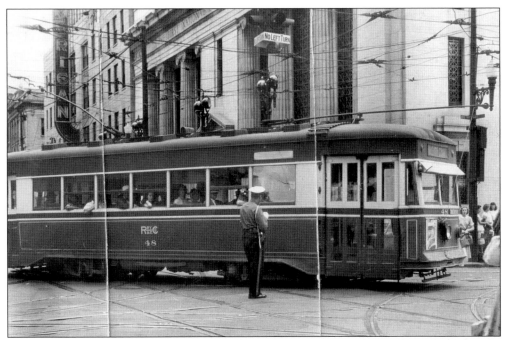

No chapter on streetscapes of downtown Roanoke would be complete without a picture of a streetcar. Here is the No. 48 car from the Roanoke Railway and Electric Co. at the intersection of Jefferson Street and Campbell Avenue in 1948. According to its sign, the car is heading to Raleigh Court. (HMHSWV.)

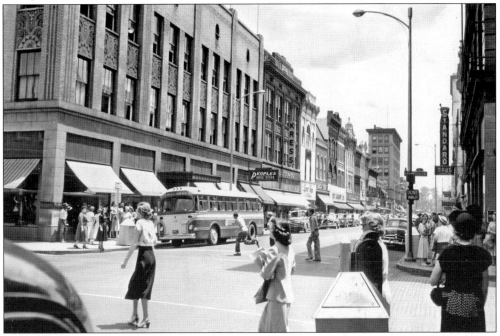

The 1950s were probably the high point for downtown retail. Here is Campbell Avenue, looking east from First Street. Stores included People's Drug, Kress and Co., Lerner Shops, Lerner Shops for Children, and W.T. Grant and Co. (HMHSWV.)

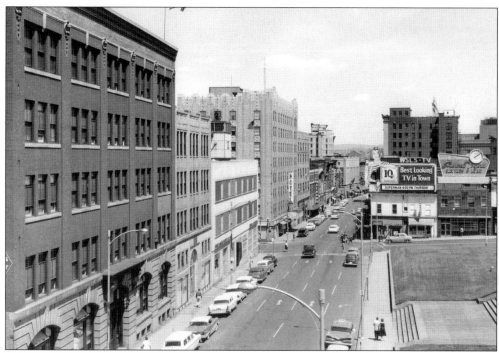

This is another view of Campbell Avenue during the 1950s. The lawn to the bottom right belongs to the Municipal Building. The sign in the center advertises "WSLS TV—Best Looking TV in Town—Superman 6:00 p.m. Thursday." (HMHSWV.)

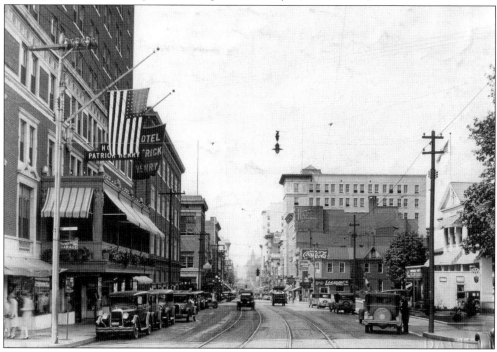

This is Jefferson Street looking north in 1927. The Patrick Henry Hotel is on the left; the Yellow Cab Co. and the Elks Home are on the right. (HMHSWV.)

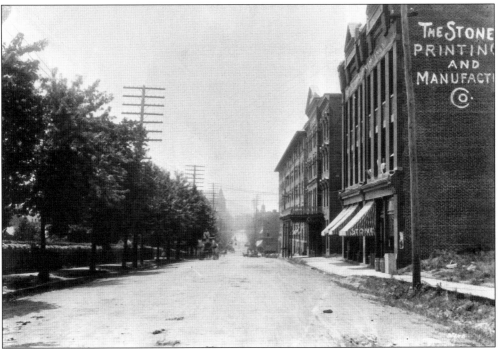

In 1915, Stone Printing and Manufacturing Co., the Stratford Hotel, and the N&W general office building occupied this block of Jefferson Street behind the Hotel Roanoke. (HMHSWV.)

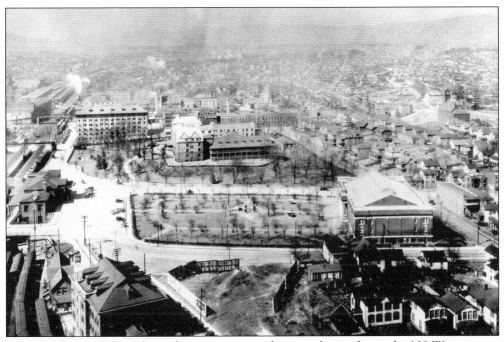

This aerial view, taken about the same year as the one above, shows the N&W passenger depot on left, the Hotel Roanoke in the center, and the Roanoke Auditorium in the right foreground. (HMHSWV.)

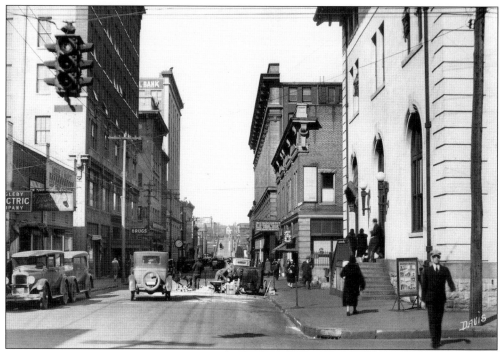

This view shows First Street, *c.* 1925, at the intersection with Church Avenue. The federal post office is to the right. Visible store signs include Tinsley's Jewelry Co., Singer Sewing Machines, and L. Savage and Co. (HMHSWV.)

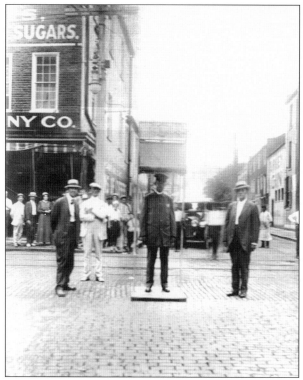

Before the lighted intersection, a policeman often managed traffic. In this 1925 photograph, a traffic cop handles matters at the intersection of Salem Avenue and First Street. The store to the left is Kenny Co. (HMHSWV.)

# Six

# HOUSES OF WORSHIP

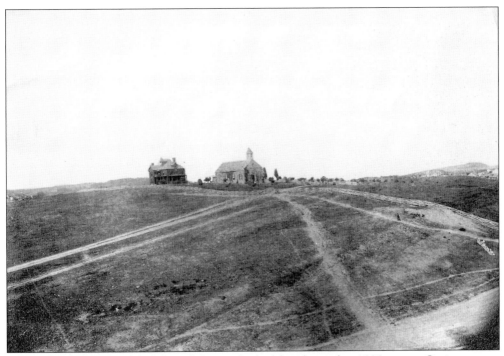

St. Andrews Catholic Church and rectory looked lonely in this 1883 image. Sitting atop a knoll, the location was largely undeveloped at that time, but it would not remain that way for long. (HMHSWV.)

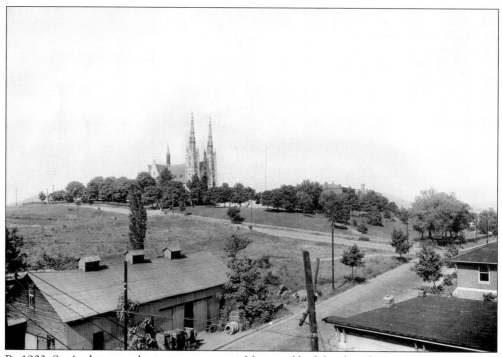

By 1903, St. Andrews was beginning to get neighbors and had developed its park-like grounds. At one time, the spires of St. Andrews were the highest point in the downtown area. (HMHSWV.)

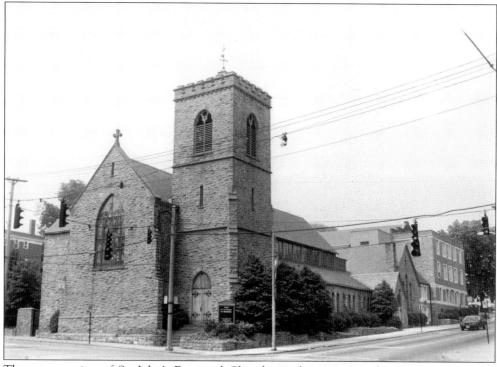

The congregation of St. John's Episcopal Church is a long-time resident of downtown. St. John's is one of the oldest still-established congregations in the city. (HMHSWV.)

Here is the original sanctuary of the First Baptist Church, on Third Street. It was located where the Verizon building sits today. (HMHSWV.)

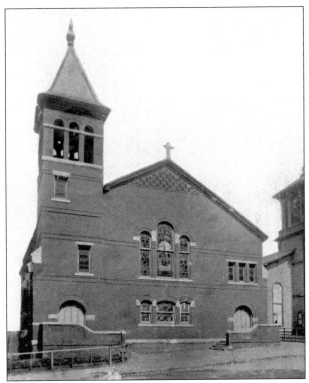

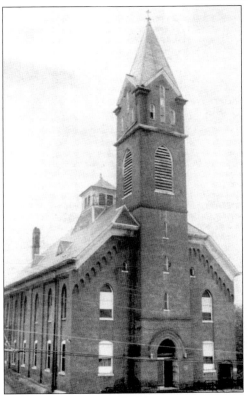

This is the old sanctuary for the First Baptist Church of Gainsboro. The congregation met here from 1900 until 1982 when they moved into a new building. Unfortunately, the structure was destroyed by fire in the late 1990s. (HMHSWV.)

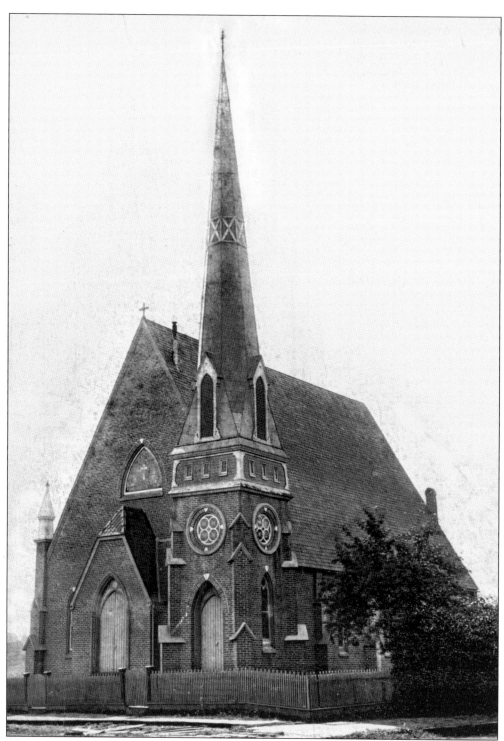

This was the original sanctuary for St. Mark's Lutheran Church on the corner of Church Avenue and Second Street, where Greene Memorial Church is today. The structure was erected in 1883 and razed 10 years later. (HMHSWV.)

The second location for St. Mark's was on the corner of Campbell Avenue and Third Street. This photo was taken in 1904. (HMHSWV.)

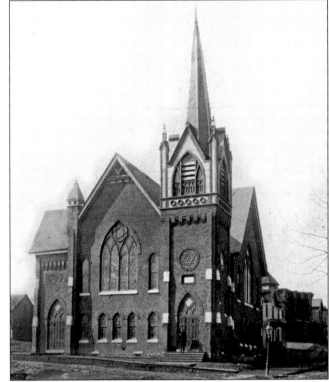

The St. Mark's congregation relocated a third time to Franklin Road in the Old Southwest neighborhood. Consequently, the former sanctuary was no longer needed. It was being razed when this photo was taken on June 21, 1956. (HMHSWV.)

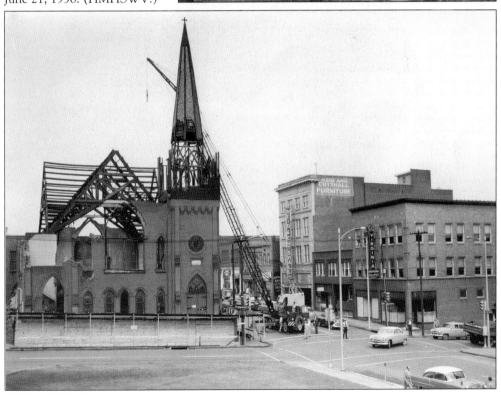

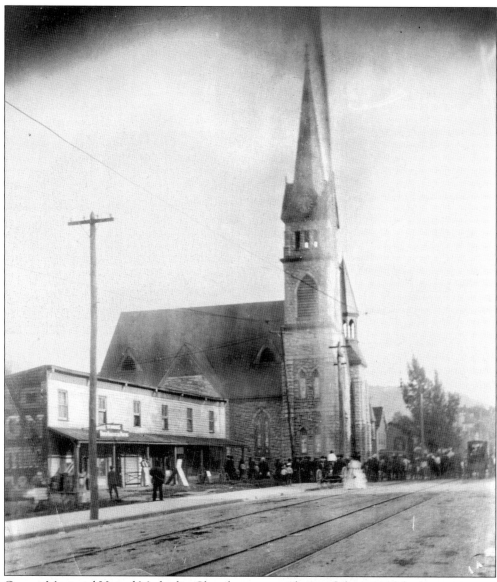

Greene Memorial United Methodist Church was erected around the turn of the last century on the corner of Church Avenue and Second Street. In this particular photograph, a steam engine is being tested for pressure and the height it would shoot water. (HMHSWV.)

Hott Memorial United Brethren Church was located at the corner of First Street and Tazewell Avenue, diagonally across from Elmwood. The congregation met at this location from 1908 until 1930. (HMHSWV.)

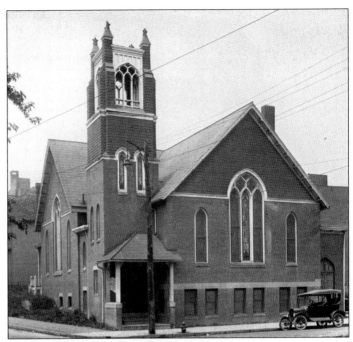

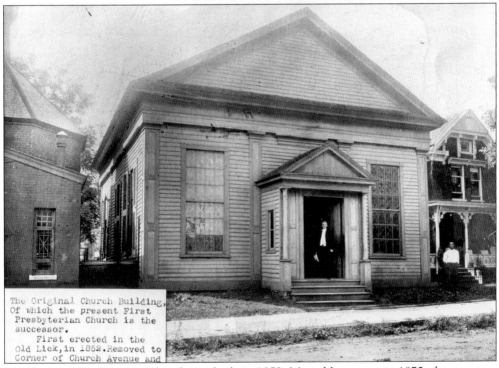

The Original Church Building, Of which the present First Presbyterian Church is the successor.
First erected in the Old Lick, in 1852. Removed to Corner of Church Avenue and

The Big Lick Presbyterian Church was built in 1852. Moved by oxcart in 1875, the structure shown above was relocated to the corner of Church Avenue and Third Street. It remained the Presbyterian's sanctuary until 1888, when a new one was constructed. The building was dismantled and moved a final time to Norfolk Avenue where, until 1953, it served as home to the Jerusalem Baptist Church. (Courtesy of First Presbyterian Church.)

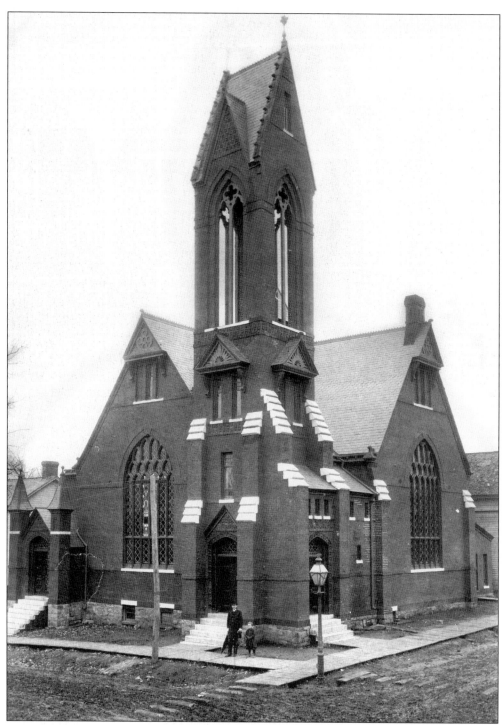

In 1888, the congregants of Big Lick Presbyterian Church, now known as First Presbyterian Church, erected their second sanctuary. The building was located on the same corner as the first, which had been moved over one lot. First Presbyterian met here until 1929. (Courtesy of First Presbyterian Church.)

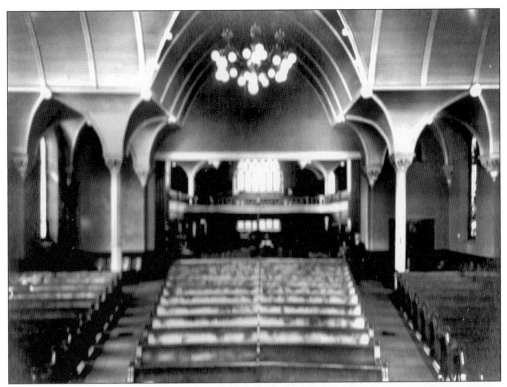

The interior of the First Presbyterian Church is shown as it looked around 1920. (Courtesy of First Presbyterian Church.)

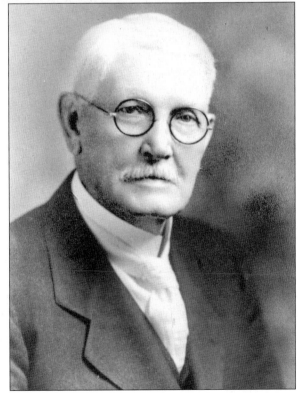

Dr. William C. Campbell served as pastor to the First Presbyterian Church from 1881 to 1923. He was deeply involved in the civic affairs of early Roanoke. In fact, he is credited with single-handedly ending the riot in Roanoke in 1893, a riot that resulted in the deaths of nine citizens. When Dr. Campbell died in 1936, local historian Raymond Barnes said there was no one more loved in the city than Reverend Campbell. (Courtesy of First Presbyterian Church.)

Central Church of the Brethren began with the purchase of a lot in 1921. The Grecian Ionic style sanctuary was completed in 1925, with the education building to the left added in 1955. (Courtesy of Central Church of the Brethren.)

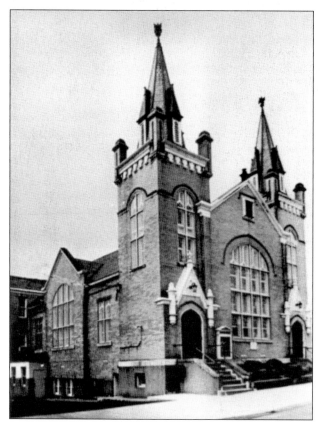

The First Christian Church's sanctuary, seen here, was built in 1910. The congregation predates the building by some 20 years, having been founded in 1889. (HMHSWV.)

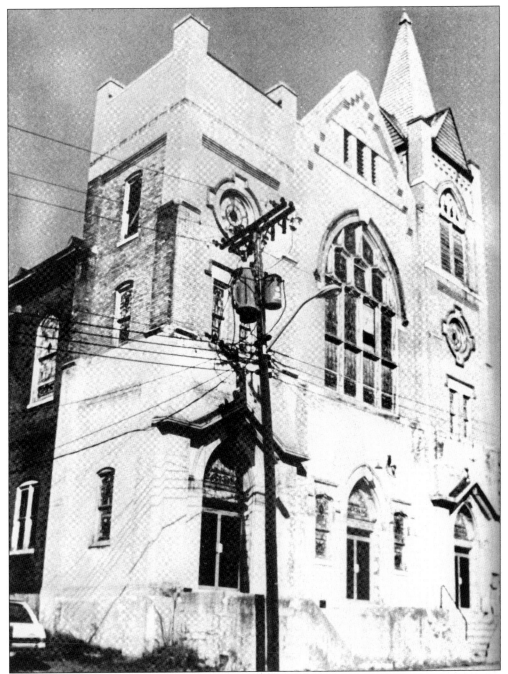

The High Street Baptist Church sanctuary stood behind the N&W general office buildings in the N. Jefferson Street area. It was the church of one of Roanoke's most respected mayors, Rev. Noel C. Taylor. The congregation moved to Florida Avenue in northwest Roanoke, and this building was razed in 1974. (HMHSWV.)

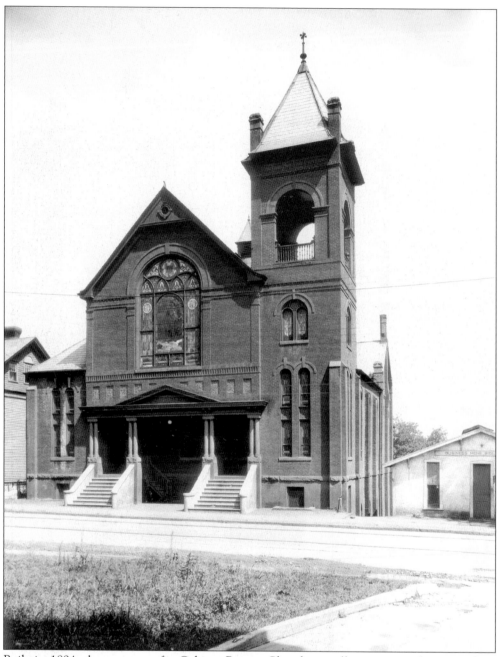

Built in 1894, the sanctuary for Calvary Baptist Church actually sat across the street from the present-day facility on Campbell Avenue. The church used this building until 1925, when the need for a larger facility caused the congregation to move into its new sanctuary. The white building adjacent was used for the Businessmen's Bible Class. (Courtesy of Calvary Baptist Church.)

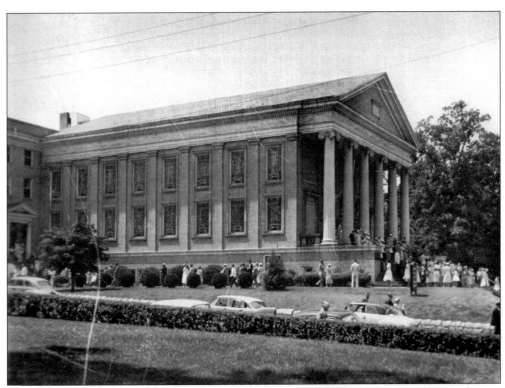

This *c.* 1960 image shows the present-day Calvary Baptist Church sanctuary that was erected in the mid-1920s. (Courtesy of Calvary Baptist Church.)

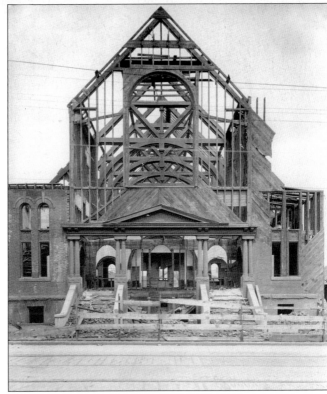

Here is the old sanctuary of Calvary Baptist Church in the process of being razed in 1931. (HMHSWV.)

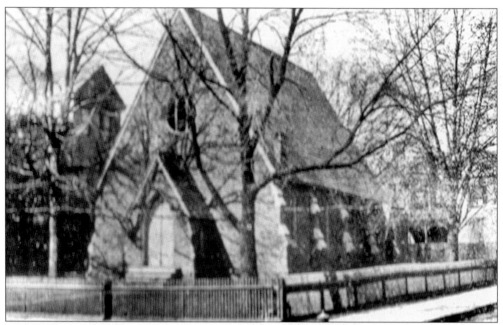

This little chapel, built in 1874 at Second Street and Church Avenue, served at least three present-day congregations. It was originally the home for Roanoke's Episcopalians. When St. John's built a new structure on Jefferson Street, the chapel served as Trinity United Methodist Church. In 1901, the Methodists built a new chapel on Mountain Avenue, so the chapel was acquired by Christ Episcopal Church as their home from 1901 until 1918. (Courtesy of Christ Episcopal Church.)

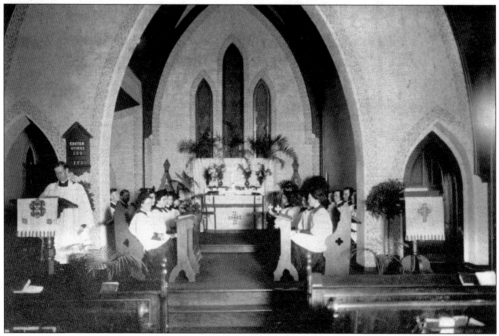

The interior of the little chapel is shown as it was used by Christ Episcopal Church on Easter Sunday in 1910. (Courtesy of Christ Episcopal Church.)

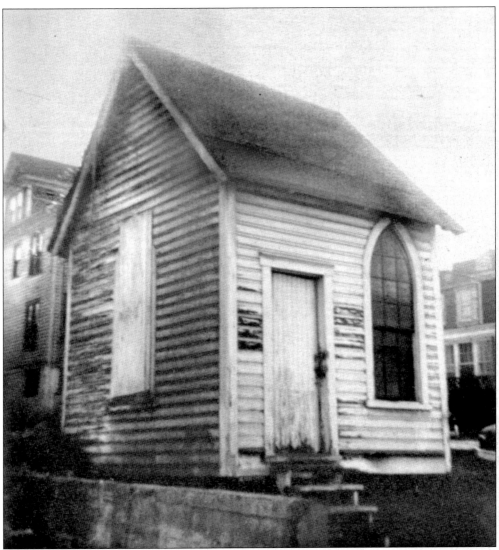

One of the last remnants of Roanoke's early church structures was this vestry of the original Christ Episcopal Church, which was still standing in the mid-1960s at 518 W. Campbell Avenue. It has since been razed, but was a part of that church's facilities when they worshiped in the 500 block of Campbell Avenue, from 1892 until 1901. (Courtesy of Christ Episcopal Church.)

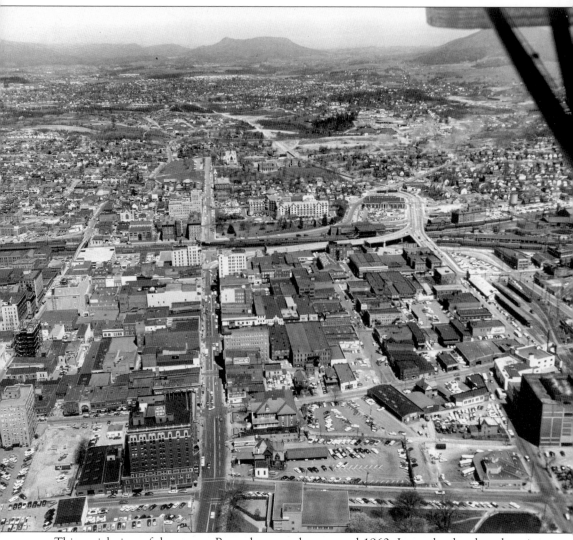

This aerial view of downtown Roanoke was taken around 1960. It can be dated to that time frame because one can see the new Main Library, which was built in 1952. Missing, however, is Interstate Highway 5-81, which was not constructed until 1964. (HMHSWV.)